LEGENDARY LOCALS

OF

# CARMEL-BY-THE-SEA

## CALIFORNIA

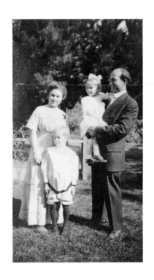

**Frank Devendorf (1856–1934) and Frank Powers (1864–1920)**
Carmel-by-the-Sea was, in the eyes of Frank Devendorf and Frank Powers, a real estate development in waiting. The developer and the San Francisco attorney partnered to purchase the parcel from Santiago J. Duckworth and establish the Carmel Development Company. They filed their map of the city in 1903 and marketed Duckworth's Catholic community as a haven for the poets, writers, artists, and academicians who would create Bohemia-by-the-Sea and launch the art colony renowned today.

Expanding upon the few homes already in existence, the Carmel Development Company built 75 cottages and, by the end of the first year, had 32 families in year-round residence, served by a livery stable, public school, telephone service, two restaurants, and two churches holding services in private homes. The city was incorporated in 1916 and grew up to reflect their vision. (Courtesy of Harrison Memorial Library.)

**Page 1**: Michael J. Murphy (1885–1959)
Michael J. Murphy was 16 when he came to Carmel from Utah, at the behest of founders Frank Devendorf and Frank Powers, to build Carmel cottages. Murphy's first commercial cottages were miniature Victorians, copies of houses he had seen in Utah. Soon, he began to add roof embellishments and other details, creating what became known as Carmel Craftsman architecture. Murphy built his first house in 1902 for his family. Today, the "First Murphy House" is a welcome center in town. (Courtesy of Harrison Memorial Library.)

LEGENDARY LOCALS

OF

# CARMEL-BY-THE-SEA

## CALIFORNIA

LISA CRAWFORD WATSON

LEGENDARY
LOCALS

Legendary Locals is an imprint of Arcadia Publishing
Charleston, South Carolina

Printed in the United States of America

Library of Congress Control Number: 2014955232

For all general information, please contact Arcadia Publishing:
Telephone 843-853-2070
Fax 843-853-0044
E-mail sales@arcadiapublishing.com
For customer service and orders:
Toll-Free 1-888-313-2665

Visit us on the Internet at www.arcadiapublishing.com

**Dedication**
*To the Carmel characters to whom this place has meant so much, and who have made so much of it*

**On the Front Cover:** Clockwise from top left:
Founders of the Carmel Bach Festival, Dene Denny and Hazel Watrous (Courtesy of David Gordon; see page 62), photographer Ansel Adams (Courtesy of *The Carmel Pine Cone*; see page 44), actor, director, developer, and former Carmel mayor Clint Eastwood (Courtesy of *The Carmel Pine Cone*; see page 79), cancer survivor and Young Cures nonprofit founder Jackie Young Salazar (Courtesy of Jackie Young Salazar; see page 114), equestrienne and artist Mari Kloeppel and horse Cobahsaan (Courtesy of Mari Kloeppel; see page 32), writers George Sterling, Mary Austin, Jack London, and Jimmie Hooper on Carmel Beach (Courtesy of David Gordon; see page 34), artist Janet Roberts (Courtesy of Janet Roberts; see page 28), singer, actress, and animal rights activist Doris Day with Lovie and Biggest (Courtesy of Doris Day Animal Foundation; see page 125), former owner of Nielsen Bros. Grocery Merv Sutton (Courtesy of *The Carmel Pine Cone*; see page 87)

**On the Back Cover:** From left to right:
The Westons, first family of photography: Chandler, Brett, Neil, Edward, Cole, and Flora (Courtesy of Brett Weston Archives; see page 45), photographer Douglas Steakley on safari in Africa (Courtesy of Douglas Steakley; see page 49)

# CONTENTS

# ACKNOWLEDGMENTS

Whether Carmel creates its characters or lures them to the storied city by the sea, a reciprocal relationship occurs, influencing who we are and how we steward this place of legendary beauty and inspiration. For every person profiled within these pages, another dozen deserve to be recognized and honored as contributors to the character of Carmel. Were there room, you would meet them as well. I have great admiration for those whose stories I was able to share and for those I was not.

In developing this tribute, which I could not have accomplished alone, I am grateful to Paul Miller, publisher of *The Carmel Pine Cone*, for his encouragement and access to his photography archives to find the faces of those who have made the news. I am grateful to Sally Aberg and Nicki Ehrlich for providing images and information about the legendary members of the Carmel Art Association. I appreciate David Gordon for his enthusiasm, photography, and insight regarding the Carmel Bach Festival. And I thank Ashlee Wright, librarian at the Henry Meade Williams History Room, for the hard-to-find photographs. And thank you, Carmel Foundation and Community Hospital of the Monterey Peninsula, for your contributions.

I appreciate artists and photographers Jeffrey Becom, Tom O'Neal, Kris Swanson, Douglas Steakley, Randy Tunnell, Cara Weston, and Kim Weston for providing photographs of Carmel characters. I appreciate Philip M. Geiger, my husband, my best friend, and my photographer, who created space in the household for me to write, took photographs when there were none, and prepared them all for publication. I thank my children, Sara and Summer, for their patience during this process. And I honor my grandmother Ruth G. Watson, a writer who taught me how to shape a story and that it should be shown and not told. She was the quintessential Carmel character.

Ultimately, I am grateful for Carmel-by-the-Sea, a personified place with a pulse and an impassioned history, whose character gives me reason to write.

# INTRODUCTION

Carmel-by-the-Sea is a living legend, a coastal hamlet that has served as both refuge and retreat, home and holiday for more than 100 years. Its story began long before its 1903 establishment as a bohemian enclave for artists, actors, poets, and professors who came to explore a cultural and creative aesthetic amid the untamed beauty of sand and sea.

Once upon a time, before Fr. Junipero Serra chose a dune overlooking the Carmel River to establish the jewel of his ministry—Mission San Carlos Borroméo de Carmelo; before Scenic Road interrupted the bank of sand rolling right through the potato patches and into the sea; before Main Street cut a dirt swath through town and later, amid great controversy, was paved and renamed Ocean Avenue; before developers Frank Devendorf and Frank Powers shored up their vision for a coastal enclave by planting hundreds of pines and cypresses, Carmel was just a rugged stretch of coastline along the dynamic waters of the Pacific Ocean.

It is simply the most spectacular stretch, where the evidence of wild forces remain in the gnarled cypress and rough, craggy cliffs whose fall is softened by native foliage clinging to the rocks en route to an unforgiving sea. The ocean, an aged chameleon whose fickle moods alternate between fits of rage and seductive stillness, never warns nor explains the beating or bathing she might offer the shore.

The first people to make their home along the Carmel coast were the Ohlones, a native tribe whose inhabitancy may date back as early as 1000 BCE. The first European explorer, Sebastian Vizcaino, arrived from Spain in 1602 to discover "another good port into which entered a copious river." It was he who christened the area "El Rio Carmelo," in honor of the Carmelite fathers traveling with him. More than a century later, in 1769, Gaspar de Portola led an expedition from Mexico to the Golden State to establish missions at San Diego and Monterey. With him was the controversial figure Fr. Junipero Serra, who, in 1771, brought "faith and fire" to the Esalen Indians and founded Carmel's Mission San Carlos de Borromeo, the jewel of his nine missions and his final resting place.

Another century passed before Santiago Duckworth, a Monterey real estate developer, began promoting Carmel as a Catholic retreat. Financial struggle led him to take on business partner Abbie Jane Hunter, who renamed the hamlet Carmel-by-the-Sea. But the depression of the 1890s was more than their business could handle.

A decade later, Devendorf and Powers brought their business acumen and wealth to the fledgling town, along with the commitment to develop a bohemian enclave by the sea. It became the ideal spot for the troubled and the talented, a place where some came to hide and others to create havoc, literature, or art. Consider Sterling and London, Stevenson and Jeffers, Austin, McComas, and Fortune, who found their inspiration by the sea.

Understandably, it is a spectacular scene, the waves rolling in from the horizon, building in strength and numbers before crashing against craggy cliffs or dissipating into a docile bay and soaking into the sand. Yet if, while strolling that one-mile arc of white along the shore, you go against wisdom to turn your back on the ocean and look eastward to the hamlet by the sea, you will find a whole different sort of special.

Stands of cypress and pine, a tapestry of many shades of green stippled by afternoon light, reach into an impossibly blue or gauzy white sky and conceal coastal Carmel cottages with their thatched or tile roofs, facades of redwood, stucco, or stone, and spray-soaked glass from which to gain vantage on the sea.

The garden gates' creative names—High Tide, Pied Piper, Sea Urchin, Mission Accomplished—identify homes in the absence of addresses. The gardens in perennial bloom, the scenic drive separating the city from the sea and going only one way to protect pedestrians from automobiles whose passengers are as engaged by the scene as they are—this is Carmel-by-the-Sea.

Carmel remains a place where legends are made, and much is made of them. It is a place that attracts a diversity of guests and claims among them, the residents, who understand who Carmel is and what it represents.

Although the city has evolved, it also has remained remarkably unchanged; its preservation is owed to the efforts of a fiercely loyal community determined to maintain the culture of a city that operates on a small scale yet achieves a tremendous reach into the world.

In the new millennium, Carmel is an alchemy of quaint and cosmopolitan. The residential community is without sidewalks or street lamps and addresses or architecture that would overwhelm the landscape. Cottages are more contemporary inside than out, many having been retrofitted to accommodate a modern lifestyle while maintaining the village facade. Within the Old World architecture of the Carmel Plaza, and throughout the walkable streets of town, the commercial matrix houses boutiques, bistros, and clothiers both couture and casual, as well as the antiques and art galleries for which Carmel was created. The town also is home to various inns and boutique hotels, as well as the historic Mission Ranch Resort.

While Carmel will never grow old, it has grown up. The town has taken to staying up later, attracting a sophisticated yet celebratory crowd that enjoys fine dining, wine tasting, good music, and cultural events such as the world-class Carmel Bach Festival, the Carmel Authors & Ideas Festival, the Carmel Art Festival, and the performing arts season. Much of it is hosted at the Sunset Center, an elementary school renovated to become a beautiful 718-seat theater and cultural hub. Carmel has always been a place of great character. One can see it in the setting, but it is most prominent in the people who make their home in this hamlet by the sea. Surely everyone who has set foot in the sands of Carmel Beach has left an imprint on the place. Those who have lingered long enough to contribute to the character of Carmel are part of the story and should be honored within the pages of this book. But that would number in the thousands, warranting a tome rather than a taste of the legendary locals. So most will not make the cut. May those who do serve as a symbol and reminder of the larger community they have created in Carmel.

In looking into the lives and studying the stories of the subjects represented, and in confirming the years in which they lived or continue to live, I found fascination in imagining lives played out within the parentheses that frame their years from birth to death—their particular moment in which they were here, making their mark on Carmel. Similarly, in sleuthing out photographs to represent each person, I realized I was holding in my hands a moment in each legendary life. And I felt honored.

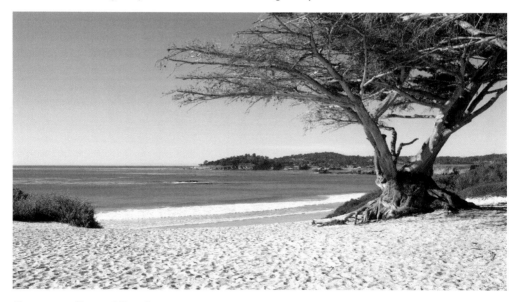

**Cypress at Carmel Beach**
Clear light illuminates the signature white sands of legendary Carmel Beach. (Courtesy of Hunter Public Relations.)

# CHAPTER ONE

# The Artists

Had the landscape been anything other than foothills sloping into the sea, a wide arc of white sand tucked into a craggy coastline framing a Pacific-blue expanse, and a place of clear light and cool summers, the artists might have gone elsewhere. In escaping a city that had toppled during the tremor of all time, the artists sought refuge in a place that seemed safe, where they could write of their angst and aspirations, paint this new Paradise-by-the-Sea, and photograph the Lone Cypress.

In a city established in 1903 and incorporated in 1916, it was reported that, by 1910, some 60 percent of Carmel homes had been built by residents "devoting their lives to work connected to the aesthetic arts."

On the afternoon of August 8, 1927, a group of 19 Carmel artists met at Gray Gables, the home of artists Josephine Culbertson and Ida Johnson, to discuss the merits of establishing an association for the advancement of art and cooperation among artists.

"The new Carmel Art Association has plenty of spunk and pep," wrote Herbert Heron, editor of *The Carmel Pine Cone* newspaper. "And, if its vivacity can be directed properly, it ought to be a good thing for Carmel." And so it has.

During the early 1930s, sculptor Gordon Newell moved to Carmel, where he had made weekend trips during school to the family cabin of a classmate. He quickly immersed himself in the community of artists and intellectuals who were building the foundation of an artist colony. Artist Dick Crispo was 10 years old when he came to Carmel from New York in 1955—the year he began painting in earnest. By age 11, he was showing his work in local exhibits. His life had doubled by the time he made his first application to become a member of the Carmel Art Association, but he was turned down. Two years later, in 1969, he became a juried member under the category of social commentary and drawing.

By 1989, artist Chris Winfield and his family of artists had moved to Carmel, where he opened his eponymous art gallery. In so doing, his contemporary gallery joined a community of, at one point, some 120 galleries as renowned and dynamic as the weather patterns by the sea. More than 25 years later, Winfield Gallery remains one of the most respected galleries in town, among a diverse community of art. What follows is a representative sample of the artists who have taught visitors and locals how to see the artistry of this area.

Josephine Culbertson (1852–1939)
She studied art at the Parker School in New York with William Merritt Chase before moving to Boston. There, Josephine Culbertson became an established artist and met watercolorist Ida Johnson, with whom she moved, in 1905, to the Bohemian art enclave known as Carmel-by-the-Sea. The pair established a studio at their home, called Gray Gables, which became a common gathering place for local artists and other creative spirits. It was from these informal meetings that the Carmel Art Association was born in 1927, and the first association meetings were held in the Culbertson-Johnson home. (Courtesy of the Carmel Art Association.)

Ida Johnson (1852–1931)
One year before the 1906 San Francisco Earthquake, which hurled many artists down the coast in search of refuge in the haven by the sea, artist Ida Johnson moved with Josephine Culbertson to Carmel. A talented watercolorist, enamored of the native plants and flowers along the coast, she supported herself largely by painting florals on china. One year after she moved to Carmel, Johnson, a founding member of the Carmel Library, was named president of the board, and served as librarian in the redwood cabin that housed the library's 500 books. In honor of Johnson's creative contributions to Carmel, the library later christened its computer system IDA. (Courtesy of The Carmel Pine Cone.)

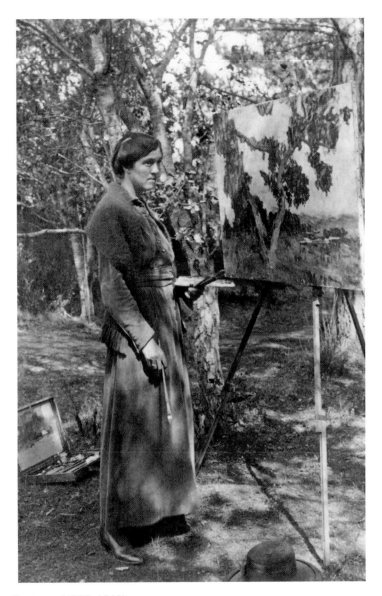

## E. Charlton Fortune (1885–1969)

Her life played out as if it had been staged. Euphemia Charlton Fortune was not the first character whose name directed her way, but she may be among the more intriguing. Born in Sausalito, California, to parents of social bearing, education, and wealth, she had the fortune of a fine mind, artistic proclivity, and the resources to make something of it. She also suffered the misfortunes of a cleft palate, the 1906 San Francisco Earthquake, two world wars, the Great Depression, and the loss of her father when she was still a child. All of it informed and altered her course.

Being born without beauty in the late 1800s narrowed her options for a career or courtship. But it made for a fine artist. Fortune was focused, determined, highly trained, and, ultimately, one of America's great impressionists. In her eyes, her name was no more appealing than her appearance. She eschewed her given name by calling herself Effie, eventually reducing it to an initial. Some say it was the name; others contend she was avoiding gender identification in the art world. Which, in Carmel-by-the-Sea, did not matter. (Courtesy of the Carmel Art Association.)

### Jules Tavernier (1844–1889)

The Carmel art colony was preceded by the 1875 arrival of Frenchman Jules Tavernier, a flamboyant bohemian artist who stayed at the legendary French Hotel until his tab at the neighborhood bar reportedly contributed to his departure in 1880. Tavernier was sent to the Monterey Peninsula by the French government with the assignment to describe the Wild West, an intrigue that later inspired *Harper's Magazine* to commission him for the same purpose. The Carmel Art Association has Tavernier's drawings of the Mesa and Southwest Native American territories, but he also is known for images painted as he traveled west out of the desert and on up to Monterey. Tavernier channeled his dynamic style into his landscapes, revealing a particular sensitivity to subject via his paintings of the Carmel redwoods and the Carmel Mission at sunset. (Courtesy of Harrison Memorial Library.)

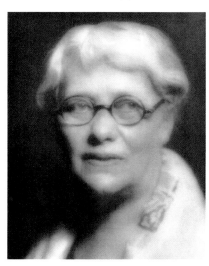

### Mary DeNeale Morgan (1868–1948)

During her years in Carmel from 1904 to 1948, Mary DeNeale Morgan had a studio on Lincoln Street right next to the famed Cypress Inn. An artist who, every day, went out to paint, work on her sketches, and mentor her students, she was always open to an audience as she worked. A landscape artist, Morgan was a founding member of the Carmel Arts and Crafts Club and the Carmel Art Association. She also became active in the Forest Theater, a community playhouse in Carmel. (Courtesy of the Carmel Art Association.)

## Jo Mora (1876–1947)

That he was born in Uruguay made him authentic. That he was raised and formally educated on the East Coast added some kind of pedigree and perhaps legitimacy to his work. Yet, that first journey in 1898 to the West, which wandered into a rambling road trip throughout the Southwest, that period when he worked as a cattle rancher in Texas, and sketched his way along the same route Fr. Junipero Serra traveled when establishing the California missions, informed the substance of Jo Mora's work. He made his first trip to California, eventually settling in Carmel in 1920, to commence what he regarded as "the supreme professional effort of his life," a memorial cenotaph of Fr. Junipero Serra. (Courtesy of the Carmel Art Association.)

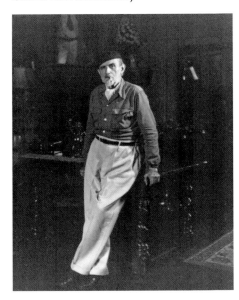

## William F. Ritschel (1864–1949)

Devoted to traditional styles of art, William Ritschel and his colleagues took refuge from the Modern movement by establishing the Early California School, focused largely on seascapes. Ritschel painted in Carmel and became a founding member of the Carmel Art Association yet preferred to present his work in what he considered more sophisticated art markets, extending his success well beyond the little hamlet by the sea. (Courtesy of the Carmel Art Association.)

### Paul Whitman (1897–1950)

In 1926, at age 29, Paul Whitman took a risk. The Denver, Colorado, native packed his paintbrushes and walked away from his family, his job, and life as he had known it in St. Louis, Missouri, to pursue his passion in an artist colony called Carmel-by-the-Sea. A year later, he sent for his wife, Anita, and their three children. Whitman entrenched himself in the art community, becoming a founding member of the Carmel Art Association. An early mentor and enduring friend was artist Armin Hansen, who taught him the intricacies of etching. In 1937, the colleagues founded the Carmel Art Institute to provide art instruction to other members of the community. (Courtesy of the Carmel Art Association.)

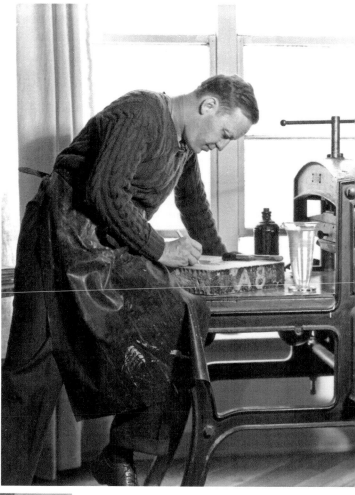

### Armin Hansen (1886–1957)

Because Armin Hansen expressed the determination of fishermen commanding waters of the Monterey Bay, many associate the painter more with Monterey than with Carmel. Yet Hansen, who was born in San Francisco and studied at the California School of Design, the Stuttgart Royal Academy, and the Academy of Fine Arts in Munich, Germany, moved to the Monterey Peninsula in 1922 to study with E. Charlton Fortune and become an active member of the Carmel art community. He joined the Carmel Art Association upon its establishment in 1927. A decade later, he and artist Paul Whitman founded the Carmel Art Institute as a teaching center to further promote art in the community. (Courtesy of the Carmel Art Association.)

## S.C. Yuan (1911–1974)

Wellington Si Chen Yuan was a Chinese immigrant who settled on the Monterey Peninsula in 1953 and became a member of the Carmel Association. Despite continued advancement in his art and what most considered appreciable acclaim for his haunting designs, Yuan was unable to see the splendor and success of his own work. Moody by most accounts, passionate and emotional by others, he was given to angry, depressed, or impulsive behavior. In 1974, despondent over what he considered a lack of widespread recognition, coupled with a failing marriage, he hung an art exhibit at the association, visited his brother John and, the next day, took his own life. Yuan's final exhibition was attended by friends, mostly artists, who purchased every painting in the show. (Courtesy of the Carmel Art Association.)

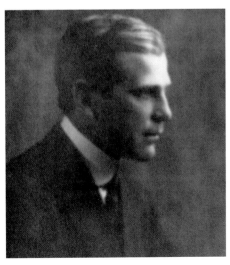

## Francis John McComas (1875–1938)

Francis John McComas, who, upon encountering the Monterey Peninsula, coined the phrase "the greatest meeting of land and water in the world," arrived in 1899 from Tasmania and remained on the Peninsula until 1938. *The Mountain, The Old Castro Adobe*, and *The Monterey Oaks* are among his more famous watercolors, although he also was known for his many area murals. Among the more prominent are those that remain in the old Hotel Del Monte, which now houses the Naval Postgraduate School, along with his legendary map of the Peninsula. (Courtesy of the Carmel Art Association.)

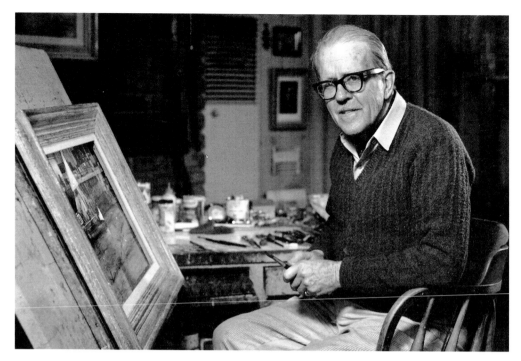

Donald Teague (1897–1991)
Born in Brooklyn and trained at the renowned Art Students League in New York, Donald Teague became an illustrator for *The Saturday Evening Post*. After moving to California in 1938, he doubled as a Western illustrator for *Collier's* magazine, his work inspired by youthful summers spent on a ranch in Colorado. Upon his retirement in 1958, Teague turned his attention and his devotion to painting. Considered one of the premier watercolorists of the last century, Teague enjoyed international recognition and numerous awards, exhibiting his work in museums and galleries around the world, including Carmel. (Courtesy of *The Carmel Pine Cone*.)

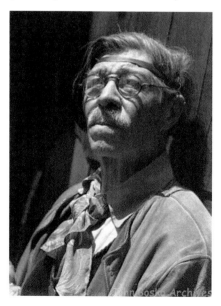

Xavier Martinez (1869–1943)
Best known as a California tonalist painter and art educator, Xavier Martinez's relationship to Carmel began in 1907, when he was invited to open a gallery at the Hotel Del Monte in Monterey. The opportunity motivated him to move with his wife, Elsie, to Carmel, where he became a member of the Carmel Art Association. Born in Mexico, Martinez moved to San Francisco in 1893 and enrolled at the California School of Design. He continued his art education in Europe, attending the École des Beaux-Arts on a scholarship awarded by the Bohemian Club—a private San Francisco fraternity that appreciates the arts. (Courtesy of John Bosko Archives.)

**Charles Rollo Peters (1862–1928)**
From 1900 to 1909, Charles Rollo Peters painted on the Peninsula. His family estate remains behind what is still Peters Gate, a residential enclave in Monterey. Famous for his nocturne style of painting, he was equally known for his legendary parties, which included friends from San Francisco. After taking the train from the city to the Hotel Del Monte, guests were delivered to the artist's home and studio via stagecoach, where they would party throughout the weekend, participating in antics that might include the building of a rock wall, painting, or perhaps a stretch of pure celebration. (Courtesy of Harrison Memorial Library.)

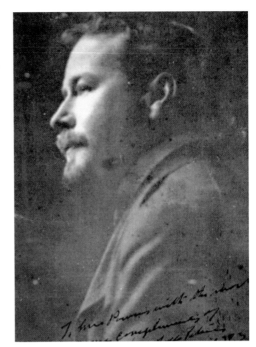

**Alexander Weygers (1901–1989)**
Born in Java, Indonesia, and trained in Holland, Alexander Weygers left his architectural career and eventually settled in Carmel Valley during World War II, where he crafted a life for himself and his wife, Marian, out of natural resources and artistic vision. He was an artist who forged his tools and then used them to create art. Those were the days when handpicked students, either laboring by his side or clustered at his feet like the scholars of Socrates, learned as much from Weygers about the art of living as they did about art. (Photograph by Jim Ziegler, courtesy of Peter Partch.)

### Wah Ming Chang (1917–2003)

By the light in his eyes and a wry smile that revealed both wisdom and humor, one might have assumed that Wah Ming Chang was a wizard. By appearances, he was elderly and frail, largely owing to the braces fettering his gait after polio. But he was never old. When he died, just days before Christmas, Chang was filming animation, sculpting, and illustrating a children's book. His work would never be finished, so he simply left when he was.

Inside the timeworn bindings of photograph albums are the reminiscences of Chang's prolific career. He made puppets and posable figures of Pinocchio and Bambi from which Disney animators drew. He worked on the original *Fantasia*. His animation on *The Time Machine* earned him an Oscar for special effects. Chang later became a fine art sculptor; his work, largely in bronze, was, in its simplicity, sensitive and subtle. (Courtesy of the Carmel Art Association.)

### Eyvind Earle (1916–2000)

The only thing more difficult to define than an Eyvind Earle painting is likely the enigma himself. And the chances of getting either wrong are equally strong. Earle's paintings are complex yet simple. They are cool shadows and warm light—wicked, yet wise. The best way to interpret an Eyvind Earle painting is to note the contrast between dark and light, subtle and bold—the broad, sweeping strokes and minute detail. His painterly style is, simply, Eyvind Earle. When he was 10 years old, Earle's father gave him a choice; he could either read 50 pages of a book or paint one piece, every day. He chose both. In the 1959 story of *Sleeping Beauty*, Earle found his inspiration and his future. (Courtesy of Eyvind Earle Publishing LLC.)

### Gordon Newell (1905–1998)

His is the story of a weak little boy with a faint heart, who finally freed the sword from the stone, then used it to sculpt a butterfly. Had he not become a sculptor, Gordon Newell probably would have been a poet, so enamored was he of literature, particularly poetry by Robinson Jeffers, whom he met in a poetry class at UC Berkeley. Newell studied form with San Francisco sculptor Ralph Stackpole, with whom he apprenticed. Three years later, he moved to the Carmel community of intellectuals and artisans who were building the foundation of an artist colony. He saw Jeffers walking along Carmel beach and asked to help sculpt his Hawk Tower. He found the poet gentle and kind, but determined to work alone, citing his stone work as the gestation for his writing. Newell understood. (Courtesy of Jeff Garner.)

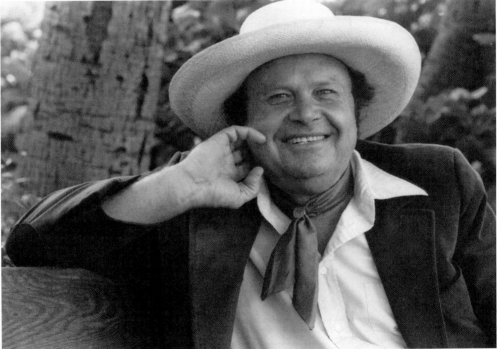

### Emile Norman (1918–2009)

To understand Emile Norman, simply study his work. Ponder the sleek sculptures of animals and other treasures of nature, the rich and rare woods, and the seemingly impossible placement of pieces whose mosaics created the substance and form of his art. Tirelessly he worked in his studio, carefully placing minute shapes of rare and precious woods or colorful crushed glass into his endomosaic sculptures, much the way he collected equally rare and precious people around him. Each, in his eyes, was an integral part of the inner sanctum of a truly artistic life. The other art form he loved as much as his mosaics was music. A man whose life focused on design, he considered Bach the definitive designer of music; someone who, like himself, believed a medium should be taken to its limits but not overdone. (Courtesy of *The Carmel Pine Cone*.)

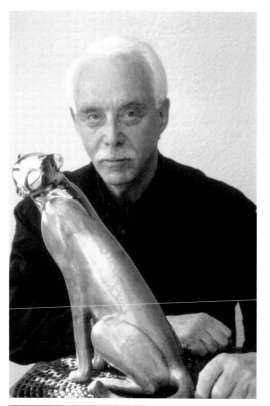

### Loet Vanderveen (1921–2015)

In 1985, sculptor Loet Vanderveen lost nearly everything but his life in a blaze. Yet from among the ashes, he rose like a phoenix to begin again. It was not the first time. Vanderveen was born in Rotterdam, Netherlands, and came of age during an unkind era in Europe. In 1942, he found himself in the wrong place at the wrong time without official papers, and so did the enemy. He was captured and imprisoned in Vichy, France, until the Dutch government facilitated his escape through Spain. By the time he was in his early 20s, he had become a fixture in the world of fashion design. And by his late 30s, he had become a sculptor. Vanderveen has always been empathic to animals and fascinated by the possibilities of interpreting them. His work reveals the essence of the animal as simply as possible by introducing a minimum of detail, creating a classical quality that endures. (Courtesy of Loet Vanderveen.)

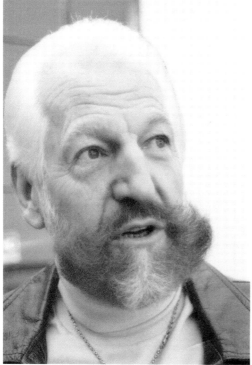

### Barclay Ferguson (1924–1991)

Barclay Ferguson was a technical illustrator for Atomic Energy in Canada before moving to the Monterey Peninsula, where his expression took a decidedly artistic turn. A member of the Carmel Art Association, he became an active participant in the local art scene. (Courtesy of *The Carmel Pine Cone*.)

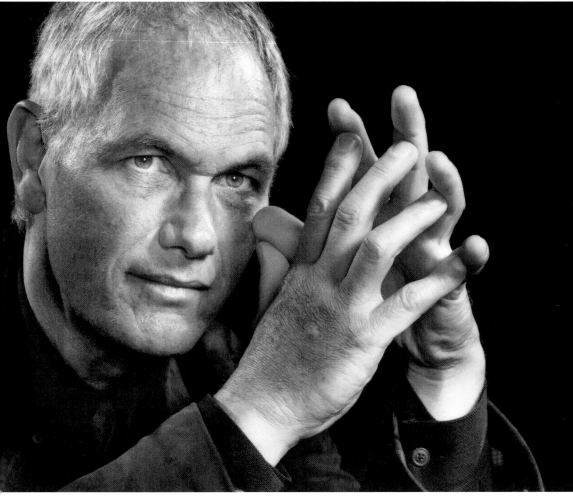

### Richard MacDonald (1946)

Richard MacDonald is world renowned for artistry that reveals a profound understanding of the human experience and celebrates the ascendancy of the human spirit. His fascination with the human form and mankind's broad emotional range has inspired him to create dynamic, sensitive works—each infused with a quality that withstands time, taste, and trend.

Born and raised in California during an unwelcoming era for figurative art, MacDonald was tossed into artistic waters by his uncle, then a leading graphic designer. The artist lived long enough to see his nephew become an illustrator of surpassing skill but not to witness his emergence into what has since seemed his birthright, figurative sculpture. His monuments, tributes to the triumph of the human spirit, offer inspiration to those who will follow the path first laid for him by his uncle. (Courtesy of Richard MacDonald.)

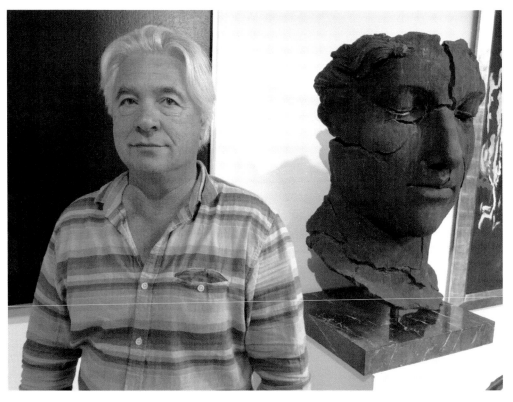

**Chris Winfield (1950)**

Chris Winfield stood in his Carmel art gallery, studying a vivid painting, as he has so often during his 25 years at the helm of Winfield Gallery, one of the most substantial galleries in town. He considered the execution of this particular abstract with a critical eye—the building and tearing down, the working and reworking, resulting in a layering of color and shape and pattern that seemed to float upon the canvas. Yet this time, he was looking at his own work. Winfield hails from a legendary local family of artists. It had to come from somewhere. (Courtesy of Chris Winfield.)

**Elizabeth Murray (1953)**

The sky is a whisper of blue, and the sun has begun to awaken the garden, where a riot of color is coming to life in the soft light of morning. Inside the red farmhouse rising out of the foliage, Elizabeth Murray has set the water to boil for tea. The artist, author, master gardener, medicine woman, and sage is easing herself and her students into a seminar loaded with life dreams, heart, and meaning. Murray is a Renaissance artist of the highest form, largely because she has the facility to infuse the reaches of her life with art, grounded in the forces of nature. Those who have experienced her work understand her inspiration is the spirit of humanity and the earth. (Courtesy of Elizabeth Murray.)

### Carol Chapman (1936)

The atmosphere of Carol Chapman's Carmel home reflects her personality as well as her art, crisp, clean lines but beachy casual. It is colorful, that brilliant, paint-with-abandon color. And her use of space, the absence and economy of it, is all very Chapman, gorgeous in her vivid abstraction, her soft expressionism, the hard edge of her renowned Cannes beach chairs, or the photorealism of her portraiture. It is just like the artist herself. (Courtesy of Carol Chapman.)

### Duncan Todd (1928–1998)

When he retired, it made sense that the man who spent 30 years teaching high school drafting and electronics was not going to start painting flowers. Duncan Todd was a precise kind of guy. He was organized, he was practical, and he was neat. He was not a simple man; he just made things look that way. His approach to ceramics mirrored his approach to life—clean lines, smooth finishes, three colorways, three patterns, stripes, checks, and polka dots. It was that simple. Seemingly overnight, his work became the hot item of the 1990s. And then he died. His community was not ready. Neither was he. He had pots to paint and grandchildren to cradle. He had Carol, his best friend and wife of 45 years. And he had a twinkle in his eye that promised no matter how bad the cancer got, it could not silence his spirit. Todd kept his promise. (Courtesy of Carol Todd.)

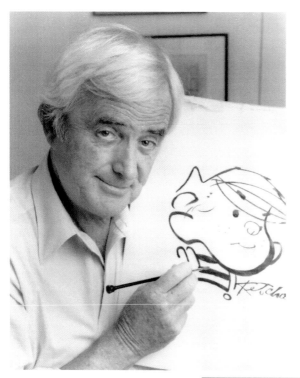

**Hank Ketcham (1920–2001)**
Henry Ketcham was in the first grade when he witnessed magic in the pencil sketches by an artist friend of the family. Once he got a hold of that pencil, the magic was his. During a dream job at Walt Disney Studios, Ketcham worked on *Pinocchio*, *Bambi*, and *Fantasia*. He later freelanced in New York for *The Saturday Evening Post*, *The New Yorker*, and *Collier's*, before moving to the Monterey Peninsula. When his first wife, Alice, complained about the behavior of their son Dennis, the idea of Dennis the Menace hit home. Ketcham made a commitment to the cartoon, which lasted 50 years. Toward the end of his life, he went "from Menace to Matisse," as he named his foray into fine art, effectively leaving Dennis in the hands of artists Ronald Ferdinand and Marcus Hamilton to continue the legacy. (Courtesy of *The Carmel Pine Cone*.)

**Alex Anderson (1920–2010)**
In their retirement, legendary cartoon characters Rocky and Bullwinkle spent their golden years living near Carmel, along with Dudley Do-Right, Crusader Rabbit, and a host of other characters at the home of their illustrious creator, Alex Anderson. Rocky and Bullwinkle entered the artist's imagination completely unannounced. When working on a cartoon, Anderson used to say, "It happens in your dreams; they're there, these characters, waiting." He once dreamt that he went to a poker party and a moronic moose followed him into the room, doing card tricks. The moose eventually became the beloved Bullwinkle. Rocky showed up later as the voice of reason. (Courtesy of Marcia Perry.)

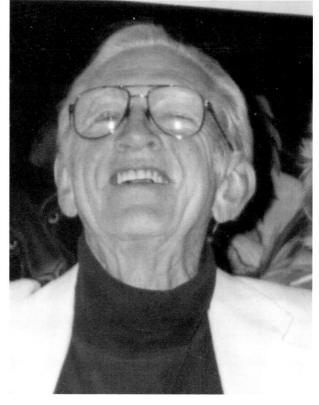

## Gus Arriola (1917–2008)

*Gordo*, he used to say, was not his fault—not in the beginning. MGM animator Gus Arriola had been assigned to design characters for *The Lonesome Stranger*, and they wanted Mexican bandits. One of them was a fat little fellow, which inspired the kind of character he wanted in the comic strip he was developing. He made him a bean farmer and named him Gordo. The strip, which ran from 1941 to 1985, introduced many Americans to still-popular words and phrases from Spanish, such as hasta la vista, amigo, piñata, compadre, muchacho, and hasta mañana. Legendary *Peanuts* cartoonist Charles Schulz reportedly called *Gordo* the most beautifully drawn strip in the history of comics.

Yet it was not until Arriola visited Mexico that he got a sincere sense of the Mexican culture and became enamored of their folk art. Once he understood he was depicting real people in a real country, he cleaned up the dialogue and lost the contrived accent. Many fans were upset by the changes, but more, in a new era of cultural sensitivity, were soothed. (Courtesy of *The Carmel Pine Cone*.)

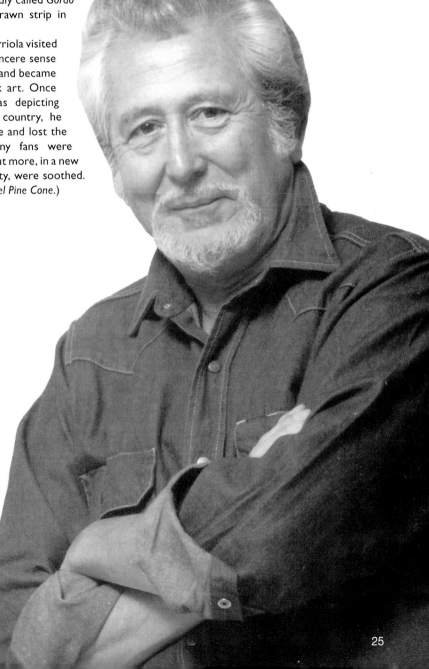

25

### Eldon Dedini (1921–2006)

The bus stopped at every farm on the way up the valley from King City, picking up kids headed to Salinas Junior College. Eldon Dedini's interest was art, but he took general studies in case his talents didn't prove marketable. Especially since his concentration was cartoons. Before he finished school, Dedini had littered *Colliers*, *The Saturday Evening Post*, *Esquire*, and other magazines with gags and cartoons, and they did the same to him with rejection slips. The only thing he decided to keep was the lesson: Be fearless and have an endless amount of gags. For an artist who sold his first cartoon to *The New Yorker* in 1950 and premiered with a cartoon in *Playboy* magazine nine years later, it was only the beginning of an illustrious career that would not cease until Dedini ran out of gags. (Courtesy of *The Carmel Pine Cone*.)

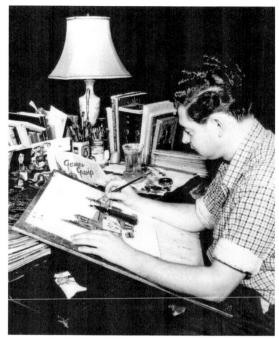

### Dick Crispo (1945)

Dick Crispo learned to paint as a teenager by hanging out with legendary local artists as if he were one. And now he is. The longtime member of the Carmel Art Association knows the storied culture of Carmel, and his artwork provides a most eloquent autobiography. Painting is his conversation, and the mural has often been his medium of expression. In 1965, he read *The Fabulous Life of Diego Rivera* and fell in love, not always with Rivera or his work, but clearly the concept of the mural. Crispo has since completed more than 60 murals across the country. (Courtesy of the Carmel Art Association.)

**Bill Bates (1930–2009)**

Two weeks after cartoonist Bill Bates moved to Carmel, he made the transformation from tourist to townie. He had not only observed the culture of Carmel, he had become part of it. He saw that a driver could expire at an intersection before the trail of tourists abated long enough for him to proceed. He understood that seniors scoffed at tourists, and the population under 18 was a transient crowd just there to visit grandparents. He learned that it took a permit to wear high heels, eat ice cream, or chew gum in town. He recognized that the houses were far more expensive than the landscape but not nearly as valuable. And he poked fun at it.

More than 30 years and some 1,500 cartoons later, Bates had become a legend, part of the lore and the lure of Carmel and its characters. He published five books and, in 1998, was personally bestowed, by the mayor of Carmel, with the "Humor Overlay District," a perpetual two-foot radius of wit encircling the artist. (Courtesy of the Carmel Art Association.)

## Pamela Carroll (1948)

She is an artist who paints an artichoke like one could pick it, dip it, and find it ripe. Pamela Carroll says she paints only from life, focusing on those things with which people are living. Rather than painting the downy feathers and gleaming bead of an eye on the tiniest of birds—a skill and perspective she leaves to her sister Penelope Krebs—she is more likely to paint the colorful flat feathers on a tin toy bird, perched on a wooden block. And yet something in the wear of the block, the weathered surface on which it rests, and that same gleam in the eye of the bird creates a relationship with the viewer, and one believes it would be possible to hold it. (Courtesy of Chris Carroll.)

## Janet Roberts (1956)

Inside her studio works a child who grew up in Ann Arbor, Michigan, with three brothers and no mother, the girl who survived violence and abuse through imagination, the teenager who gave pony rides to pay for art school, the student who put college but not creativity on hold to have babies, the mother who raised four daughters, the woman who beat cancer three times, and the artist who sees beauty in everything around her. This is why Janet Roberts' paintings are neither angry nor dark, tormented nor trying. And why, having raised more than $1 million for at-risk children and cancer-support communities worldwide, her work and her life are a testament to the healing power of intention. (Courtesy of Janet Roberts.)

**Miguel Dominguez (1941)**

When Miguel Dominguez dips his brush into watercolor, the primary subject of the battered barn in the shadows, the forest fading into evening light, or the weather-weary fence is simply an invitation to feel. He is just as apt to paint the hush in the air, the serenity of the setting, or the solitude of the moment. Dominguez was born into an all-Mexican neighborhood along the Rio Grande. When he moved with his family to Monterey County, his transition was eased by a facility for self-expression that surpassed language to expose thought and feeling through art. Something about a Dominguez landscape tells viewers they have been there before. Perhaps it is not the place but a particular feeling they are revisiting, a kind of solitude rarely sensed except at dawn on Sunday or just before sleep. (Courtesy of Miguel Dominguez.)

**Alicia Meheen (1936)**

The numerous shades of green textured the distant range. Augural clouds darkened an early sky, muting a palette of wildflowers, dappling the horses, and shrouding the barn. But she was focusing on the narrowest sliver of light just above the hills; her brush quickly filling in a composition crafted around one argent ray breaking through the darkness. Alicia Meheen attributes much of her technique and style to years of consistent on-location painting and evaluation. To this day, she faithfully fills a small backpack with painting essentials and a simple radio, grabs her folding stool and a canvas, and heads out to paint, plein air. With the dial turned to K-BACH, she loses herself in the music and paints what she feels. (Courtesy of Jeffrey Becom.)

### Jan Wagstaff (1948)

Artist and teacher Jan Wagstaff found it a challenge to keep children open to and interested in the natural world. Ultimately, she realized, in working from direct observation where students were forced to deal with active emotion and self assessment, they found their way. Wagstaff keeps herself on the edge of expression, appreciating the natural beauty inherent in marshland grasses, shivering in the breeze, in burnished coins creating a quaking canopy above otherwise barren aspens, or in a bird whose eider down flutters in the early air. As an artist she responds to the texture, color, movement, and shape she sees in the landscape. As a teacher, she adores the creative dynamic in the classroom. (Courtesy of Jan Wagstaff.)

### Christine Rosamond (1947–1994)

She had hair the color of coffee and eyes that held an ocean of depth. Christine Rosamond painted women, possibly because she understood them best, yet perhaps to understand them better. In each subject, large, wide-set eyes confronted the viewer, creating a desire to know more about the subject, the artist, the self. By the early 1970s, her work was a household image, selling by the millions as posters, limited editions, and original art. At the time, she was branded the "most published artist in the world." In 1994, at the height of her career, Rosamond was swept from her success story by a rogue wave off the Big Sur coast as she wandered the tide pools with her sister and then-eight-year-old daughter. Her sister saved the child. Rosamond succumbed to the sea. She was 46. (Courtesy of *The Carmel Pine Cone*.)

30

**Belle Yang (1960)**

If people are fortunate, their lives will not go as planned. Belle Yang was born on the island of Taiwan in an unkind era, a legacy of centuries of similar tradition. Her father, an artist seeking freedom of voice, brought his wife and child to America, where, in exchange for freedom, he gave up his voice. They learned to speak English. They celebrated citizenship and settled in the city by the sea where they later hosted many art exhibitions. Their paintings are their stories.

Yang studied at the Art Center College of Design in Pasadena, California, and returned to Carmel, where all her father had sought for her in the promise of America was ransomed by a stalker. Escaping violence, burglary, fear, and isolation, she returned to China. Yet after a young student lay dying in her arms in Tiananmen Square, her spirit sought refuge in her return to Carmel, where she has become a prolific artist and writer. (Courtesy of Belle Yang.)

### Mari Kloeppel (1961)

She knew, as surely as she knew she was dying, that this was not her moment to die. This meant saving herself, which involved getting up, which required moving. But all she could muster was a slight twitch of two fingers from where she lay, her head and shoulders pressed into the earth beneath a 1,000-pound horse; her horse, Cobahsaan, an Arab gelding that had tripped in a foxhole and somersaulted before landing upon her, knocking out his wind and his rider.

In a conscious moment, she could taste the dirt clogging her mouth, smell the musky soil sifting through her air, feel her ribs breaking, one by one. She wiggled her fingers. Lodged in Cobie's nostril, they awakened the horse, which leapt up, kicking her in the head and breaking the rest of her ribs. Her lung collapsed, and air leached out like disappointment. Frightened by this unconscious form gurgling in the dirt, Cobie ran off, abandoning her, but ultimately attracting attention and assistance back at the ranch from which the two had set off for a ride.

As she lay in the hospital, battered and broken and temporarily blind, caught in a battle of wills between her spirit and herself, Mari Kloeppel realized, with the sudden stillness that comes with conviction, that she was meant to be an artist. And she promised herself and her horse, if she were to recover her sight, she would clear her life of all distraction and paint what she knew and understood about animals.

More than 20 years later, Kloeppel is an established artist who lives in the Monterey Bay area and whose paintings have a national and international reach. Although her principal subject is the horse, and her focus is exclusively animals and aviary, her paintings are less about the creatures and more about the connection she has with each. Viewers sense, in looking at a Kloeppel composition, that the dog would love them, the horse would be gentle, and the rabbit would be warm. (Courtesy of Mari Kloppel.)

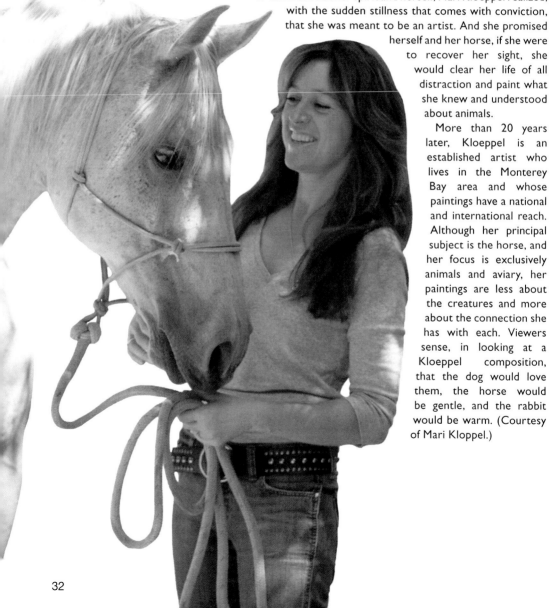

# CHAPTER TWO

# The Writers

Seashells do not litter the white sand of Carmel Beach. That does not mean one will not discover some here or there, a scattering of limpets, on occasion, a sand dollar. Some beachcombers, who know how and when and where to look, treasure them in a vessel on the coffee table. Others enjoy them where they find them.

Carmel writers are like seashells, seemingly scarce, unless one knows where to look. But they are there, having come with their pencils and pens or perhaps a tablet to find inspiration in the windswept sand and crashing waves, the craggy coast and sculptural cypress in this place of legendary beauty. It is hard to catch them in the act of their unique creativity, tucked into their inspired places at hours both early and late, when the mood and the moment collide. To the writer, this life is essential. Through rain and fog and occasional sun, during tough times and peaceful moments, economic downturns and political uprisings, the Carmel writers have something to say. Some make a living at it; others make a life. It is who they are and what they represent.

A century ago, Carmel citizens were fighting to avoid paving Main Street. In fact, many came to avoid the urbanization of their existence, to find their spirit and their home in the coastal reaches of Carmel. Here, they knew they could express themselves and their surroundings, could write what they saw and felt, and share it, if not with the world, then with each other.

Ever since the early days of Carmel, when Devendorf and Powers developed the city by the sea as a haven for artists and writers, this has been a place where writers wander in the sunlight along the shore, crafting their characters as they stroll the sand. Some slip out onto the deck as the fog rolls in, tuck into a chair and sip something steaming from a mug as they endeavor to write a brooding novel. Others gather in living rooms and coffeehouses in various degrees of informality to read their words or talk about them. Writing is, after all, a solitary business—except when it is not.

At the turn of the last century, writers Jack London, Mary Austin, George Sterling, and others enjoyed sitting in the sand by the Carmel Beach and Bath House to take time off from writing yet continue the conversation. Nearly a century later, Carmel writers gathered at the home of prolific author and editor Maxine Shore, who convened the Carmel Writers' Workshop throughout the 1990s. Writers continue to collect in coffee shops around Carmel, most notably the novelists, who take the corner tables for an afternoon of good grammar and great coffee.

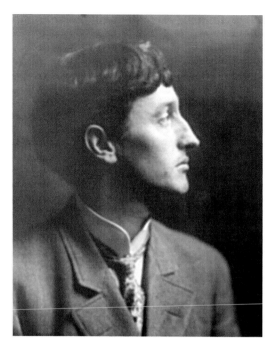

### George Sterling (1869–1926)

Born in New York, George Sterling came from prominence and was determined to keep it. After following his uncle to San Francisco to work in real estate, he became entrenched in the bohemian literary society of the City and enamored of the art colony in Carmel-by-the-Sea. Artist Charles Rollo Peters and mentor Robinson Jeffers were influential in Sterling's move to Carmel, where he spent six celebratory years in a house his aunt purchased for him in Carmel Woods. Despite a rich imagination on the page and on the stage and considerable acclaim for his poetry, Sterling did not achieve the notoriety he had anticipated except, perhaps, for his dramatic life and death, both by his own doing. (Courtesy of the Library of Congress.)

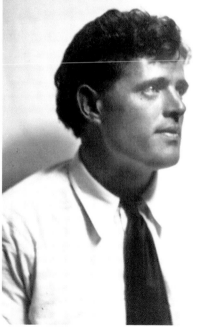

### Jack London (1876–1916)

When social activist, author, and journalist Jack London came to Carmel to visit poet and playwright George Sterling in the home Sterling's aunt had purchased for him in Carmel Woods, ostensibly it was to research the bohemian enclave for his book *The Valley of the Moon*. While Carmel ultimately did not make the cut, the coincidences are considerable. Although many of London's Carmel colleagues were not interested in the intellectual outlook of his activism, he was, nevertheless, embraced by the bohemian enclave. (Courtesy of *The Carmel Pine Cone*.)

## Mary Austin (1868–1934)

For nearly 20 years, prolific poet, playwright, and novelist Mary Austin lived in and wrote about life in the Mojave Desert. A feminist and determined defender of Native American and Spanish American rights, her writing reflected her passions and purpose. Following her heroic participation in the legendary California Water Wars, where the water relied upon by the ranches and farms of the Owens Valley ultimately was diverted to the Los Angeles Aqueduct, Austin moved to Carmel. There, in the bohemian community by the sea, the temperamental writer held her own in a decidedly male literary enclave. (Courtesy of Harrison Memorial Library.)

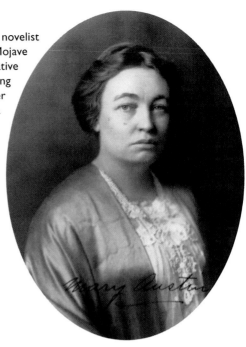

## Robinson Jeffers (1887–1962)

A dark and contemplative poet who loved fiercely, Robinson Jeffers climbed the great Hawk Tower at Tor House every night just before bed to spend time with the stars and the sea. A loner who was most comfortable in the company of his family or the solace of the sea, he left the socializing to his wife, Una. The couple, who met while both were graduate students at USC, moved to Carmel in 1914, leaving behind a story of sensation and scandal when she left her husband, prominent lawyer Edward G. Kuster, to marry the brooding young poet destined to write melancholy poems of great passion. Kuster and his second wife eventually moved to Carmel near the Jeffers home, where the four remained close. (Courtesy of *The Carmel Pine Cone*.)

**Robert Louis Stevenson (1850–1894)**
Carmel-by-the-Sea is a chameleon, a place of brilliant blue skies and the darkest nights, where coastal fog, blowing in like a balm to soften and settle the afternoon, once shrouded Point Lobos enough to, many believe, give Robert Louis Stevenson his impression of Treasure Island. The delicate man with weak lungs and a relatively short life did not visit the Peninsula often or stay long, and when he did, it was mostly in Monterey, but the caliber of his work and his connection to Carmel had sufficient impact on the area that schools and streets still bear his name. (Courtesy of California State Parks.)

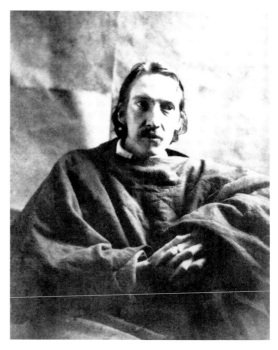

**Henry Meade Williams (1899–1984) and Mona Williams (1910–1991)**
As a young woman, Mona Williams, a writer and actress who hailed from a prominent East Coast family, went to New York City to prove herself with her short stories and novellas. Henry Meade Williams, a principal editor at *Scribner*, turned down her manuscripts but accepted her. The two married and moved to Carmel. Inspired by friendly competition, both were skilled and prolific writers—he wrote for *Collier's* and *The Saturday Evening Post*, and she handled the slicks, writing for *Redbook*, *Ladies Home Journal*, and *McCall's*. They managed to support themselves and three children, while leaving an impression on Carmel. The history room at the Carmel Library bears his name. (Courtesy of Lacy Williams Buck.)

**Maxine Shore (1912–1998)**
An author whose writing spanned many disciplines of the craft, Maxine Shore used several pen names to get published in an era when women were seen and not heard. A diminutive Carmel character with a huge personality, this elder in the Church of Christ, Scientist was the first to enjoy a good mystery, a well-told joke, and a hearty laugh. After moving to Carmel, Shore founded the Carmel Writer's Workshop, a juried league of professional writers, which she led until her passing at 86. During her tenure, she was known as a bold but benevolent editor with a wicked green pen. (Courtesy of Steven Shore.)

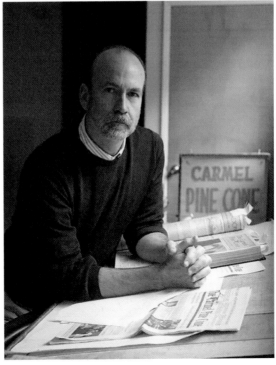

**Paul Miller (1954)**
After leaving a world-class journalism career and moving to Carmel in 1989, Paul Miller consumed the local news as a way to get acquainted with the city by the sea. A decade later, he purchased legendary newspaper *The Carmel Pine Cone*, pledging to put everything newsworthy in the pages of the neighborhood newspaper because he believed he could make a difference. A skilled and principled journalist who dives into controversy and loves a good story, particularly if it is true, ushered the paper into its centennial year in 2015. (Courtesy of Paul Miller.)

**Eric Schlosser (1959)**

Anyone who picks up a copy of *Fast Food Nation* during lunch probably chokes on their french fries. The investigative journalist and author rocketed into the spotlight with his best-selling exposé on the unsanitary and discriminatory practices of the fast-food industry, a book developed from a two-part piece in *Rolling Stone*, which later was adapted into a movie. The Manhattan-born, Princeton-educated author has since written *Reefer Madness*, *Chew on This*, and *Command and Control*, to continued success. He lives in Carmel with his wife, artist Shauna Redford, daughter of actor Robert Redford, and their two children. (Courtesy of Richard Pitnick.)

**Robert W. "Bob" Campbell (1927–2000)**

Novelist Bob Campbell used to sit in a Carmel coffee house among other writers, just to spend time with someone besides his characters. Although they were a decidedly intriguing collection, particularly Whistler, the private detection in his *LaLa Land* quartet of novels that coined the lingering line he gave Los Angeles. Campbell came to Carmel in 1975, where he kicked a smoking and drinking habit he and his fictional detective had developed in *LaLa Land*. He ultimately wrote 27 novels, 14 screenplays, scripts for 10 television series, and four stage plays, actually catching the dream he had sought. (Courtesy of *The Carmel Pine Cone*.)

**Ric Masten (1929–2008)**
The man who wrote with such insight that even the simplest words hit home is remembered as much for his eloquence as his edge, for the soaring spirit that made him both sensitive and strong, helping him turn his four-month death sentence into a nine-year stay of execution. Those who knew him and read him became one in the same, calling him a poet, philosopher, songwriter, and survivor. Although the five-time college dropout received a distinguished fellow of the arts nod from CSU Monterey Bay, neither circumstance contributed to his poetry as much as his own determination to know life, writing not of things he understood but to better understand life. Perhaps his greatest hope and advice, as a favorite poem said, was to "Let it be a Dance." (Courtesy of *The Carmel Pine Cone.*)

**Rider McDowell (1960)**
Rider McDowell, a former award-winning investigative reporter, is the author of three novels, best-selling thrillers *Wimbledon*, *The Mercy Man*, and *Forest Hills*. In 1997, McDowell cofounded Knight-McDowell Labs with his wife *Victoria*, creators of Airborne cold remedy. In recent years, McDowell moved with Victoria and their three sons from Carmel to neighboring Pebble Beach, where he continues to write. (Courtesy of *The Carmel Pine Cone.*)

### Jane Smiley (1949)

Jane Smiley believes her love of reading as a child, and her resulting curiosity as to how a story comes together, inspired her to become a writer. Born in Los Angeles and raised in Missouri, the Iowa State University professor moved to Carmel Valley in 1996. A prolific novelist, in 1992, Smiley was awarded the Pulitzer Prize for Fiction for her novel *A Thousand Acres*, which also won the National Book Critics Circle Award and, in 1997, was adapted into a film. (Courtesy of Jane Smiley.)

### Beverly Cleary (1916)

Carmel's Beverly Cleary believes an elementary school librarian was primarily responsible for developing her love of writing. After achieving a degree in library science herself, she was able to give that same inspiration to other children. Yet it is her books and the characters in them that continue to give children the chance to find themselves in her pages, as they pal around with Henry Huggins, Beezus and Ramona, Ellen Tebbits, and Otis Spofford. What she did not pull from her own childhood into her writing, she grabbed from raising her own twins. (Courtesy of Malcolm Cleary.)

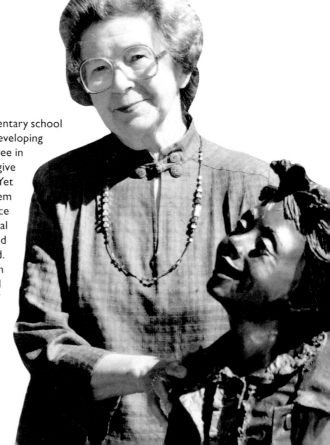

# CHAPTER THREE

# The Photographers

What is the artistry in a photograph? When photographer Kenneth Gregg came upon a crestfallen angel, soft and gentle in her suffering, yet as cool and alluring as the marble with which she had been sculpted, he took out his camera. What degree of sorrow and loss, he thought, could bring an angel to her knees? Equally drawn to her beauty and her despair, he captured her through the lens of his camera and brought her home.

Gregg's audience was as moved as he, merely upon viewing his photograph. Would they have felt what he felt upon encountering the tragic Italian statuary, or was it the emotion, the eye, and the artistry Gregg infused into the image to which they responded?

Some consider the Central Coast a haven for photography because of the beauty of the landscape, seascape, and light. Others credit the photographers who understand what it is about—the beauty and what makes it so—and know how to capture the moment when the wave reaches its crest, the bird enters flight, the rose begins to blush, and the light slips into the horizon, for those who missed it. Or would have.

Master photographer Edward Weston, considered one of the most innovative and influential among American photographers, created a legacy through his photographs and a family of photographers, among them sons Chandler, Brett, Neal, and Cole, and grandchildren Kim and Cara. The family continually invites viewers to suspend conventional expectations and open up to a different point of view.

Carmel is relentless in her beauty. Regardless of its mood, whether shrouded in fog, drenched in rain, or bathed in sunlight, the enclave puts on a consistently fabulous show, unparalleled in composition, texture, and form. The palette shifts from dusky blues and golden tones to brilliant reds until, following the signature green flash, a black curtain is dropped on the show to reopen at dawn. The photographers say it is the way light hits Carmel that reveals its beauty and inspires them to capture it through a lens in black and white or living color. The viewers admire the photographers for helping them see it. Some of them are captured here.

**Edward Chandler "Chan" Weston (1910–1995)**
The eldest son of Edward and Flora Chandler Weston, Chan Weston was a portrait photographer whose family found him warm, extremely bright, interested in everything, eccentric, inventive, and at times, reclusive. At the age of 13, Chan went to Mexico with his father on Edward Weston's first trip there, along with Italian photographer Tina Modotti. There he became fascinated with the language and culture of Mexico and enamored with Modotti. She became extremely involved in radical leftist politics, as did he, a passion that would remain with him the rest of his life. A gifted photographer, Weston seemed to suffer in the shadow of his father. (Photograph by Dorothea Lange, courtesy of Jason Weston.)

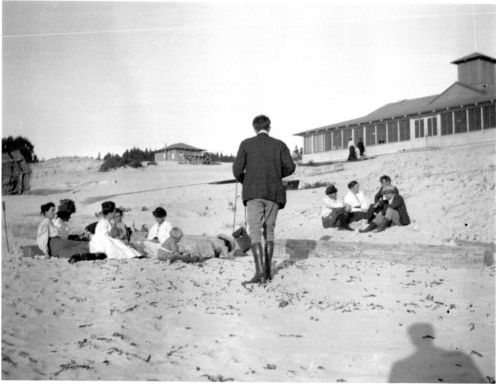

**Arnold Genthe (1869–1942)**
He awoke to the crash of his cameras across the floor of his San Francisco home and set out to borrow one from dealer George Kahn so he could record the effects of the 1906 earthquake rampaging through the city. Returning home in time to witness the explosion of his own house, Arnold Genthe spent the night camping among thousands in Golden Gate Park. He soon sought refuge in his bungalow by the sea, that coastal enclave developing as a haven for artists, writers, and other intellectuals. His legendary photographs of Carmel provide unique vantage on the nascent community. (Courtesy of the Library of Congress.)

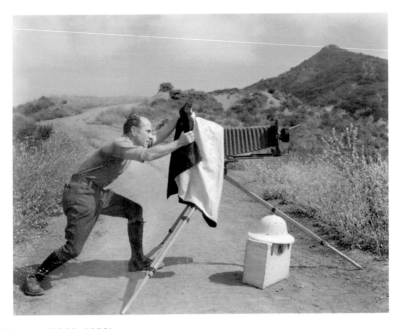

### Edward Weston (1886–1958)

His name, in the Carmel community, is synonymous with photography, with artful images that quietly invite the viewer to pay attention to something more than the subject. He has been called "one of the most innovative and influential American photographers" and "one of the masters of 20th century photography." During his 40-year career, Edward Weston photographed diverse subjects, developing a classically California approach to photography. In 1937, Weston was the first photographer to receive a Guggenheim Fellowship, awarded to those who have demonstrated "exceptional creative ability in the arts." During the next two years, he produced nearly 1,400 negatives using his 8-by-10 view camera. Some of his most famous photographs were taken of the trees and rocks at Point Lobos in Carmel, near his family home. (Above, photograph by Chan Weston, courtesy of Jason Weston; below, photograph by Brett Weston, courtesy of Brett Weston Archives.)

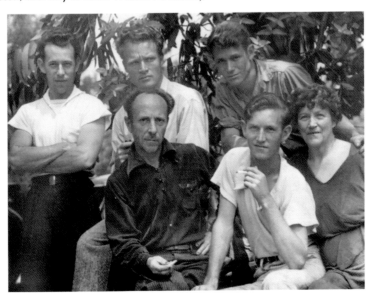

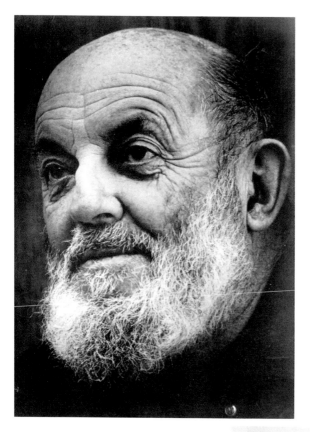

**Ansel Adams (1902–1984)**
Born into a wealthy San Francisco family, Ansel Adams's life was full of promise and privilege until his fifth year, when the family fortune was lost in the financial aftershocks of the great 1906 earthquake. Never underestimate what may rise from the ashes.

Adams meant to become a professional pianist. Raised in a Victorian atmosphere of struggle and solitude, he turned to the structure of music and the solace of nature, where he ultimately focused his lens. Adams, who developed a facility for straight photography that elevated him to the pinnacle of his profession, is celebrated for his contribution to the preservation of nature, the spectacular portfolio he left behind, and the photographers who continue his legacy. (Courtesy of *The Carmel Pine Cone*.)

**Morley Baer (1916–1995)**
As a young naval photographer, Morley Baer met his future wife, Frances, at an oyster feed in Norfolk, Virginia. Baer became her mentor and then her husband, introducing her to Carmel, photography, and a man named Edward Weston. Through regular visits with Weston, Baer both discovered and embraced the master's creed: "Simplicity, simplicity, simplicity." Baer's acquired philosophy directed his career. His instrument of photography for 48 years was an 8-by-10 Ansco view camera; his focus was often the extraordinary nature of the most ordinary of barns, plain and simple. (Courtesy of *The Carmel Pine Cone*.)

## Brett Weston (1911–1993)

Brett Weston was born to become an exceptional photographic artist. Second to the throne occupied by his father, Edward Weston, he was, perhaps, the closest to his father on an artistic level. In 1925, Weston moved with his father to Mexico to become his apprentice and begin his own photography work. Although father and son returned to California one year later, another three years elapsed before they moved to Carmel, where they kept family homes for the rest of their lives. Weston's work is distinguished from his father's by his preference for high-contrast abstraction. (Courtesy of RC Miller.)

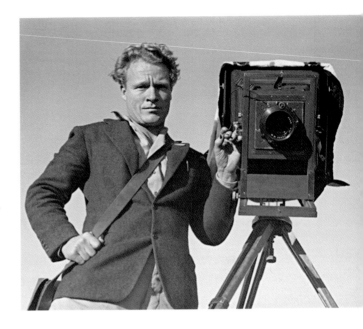

## Cole Weston (1919–2003)

Cole Weston wore a coat of many colors. Thespian, sailor, fisherman, photographer, husband, father, and friend, his passions were many and varied. Formally trained in theater arts at the Cornish School in Seattle, Washington, and experienced as a photographer for the Navy during World War II, he returned to Carmel in 1946 to work with his father, legendary master photographer Edward Weston. Although the senior Weston was world renowned for his black-and-white imagery, his son achieved worldwide acclaim for color. Weston loved photography but not more than the open sea or the theatrical stage. He was quoted that the four most important things in his life were photography, theater, sailing, and women, but not in that order. (Courtesy of Randy Tunnell.)

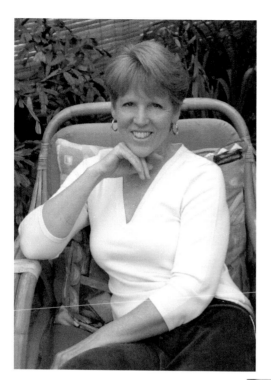

### Cara Weston (1957)

Born and raised in Carmel within the first family of photography, Cara Weston found photography a lifestyle as much as an art. Working for her father, Cole, and modeling for her uncle Brett, she honed her skills as a black-and-white photographer, ultimately stepping away from the dark room into digital photography. Although she has photographed most of her life, Weston was in her 40s before she stopped caring about being compared to the men in her family who preceded her; a freedom, she says, which came with wisdom and age. A former longtime director of the Weston Gallery in Carmel, she focuses on family and photography, the latter of which takes her all over the world. (Courtesy of Cara Weston.)

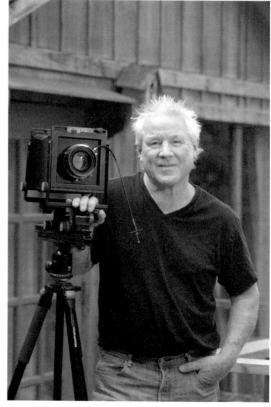

### Kim Weston (1953)

He noticed an ideal light streaming in through the skylight, illuminating one patch of flooring like a message from heaven. He quickly called in his wife, Gina, suggested she shed her clothing and reach into that kind of dawning stretch one enjoys with the morning light. The photograph has become his signature.

Kim Weston views the world through different eyes, their acuity sharpened by the legacy of his father before him and his grandfather before him, though his vision is his own. He is a Weston by birth, appearance, talent, and that singular sort of magic that renders photographic images like no other. (Courtesy of Randy Tunnell.)

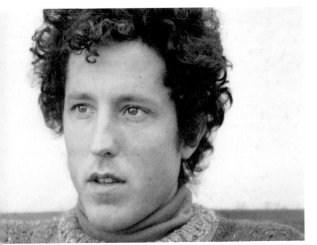

### Winston Boyer (1954)

Longtime Carmel resident Winston Boyer works as both a fine art and commercial photographer. In 1979, he traveled to Europe, where, for three years, he worked as a sports photographer for European and American publications. Boyer also has compiled photographs of European landscapes, people, and architecture and hosted numerous gallery exhibitions. During the 1980s, he traveled the country, compiling photographs for his popular book *American Roads*. (Courtesy of *The Carmel Pine Cone*.)

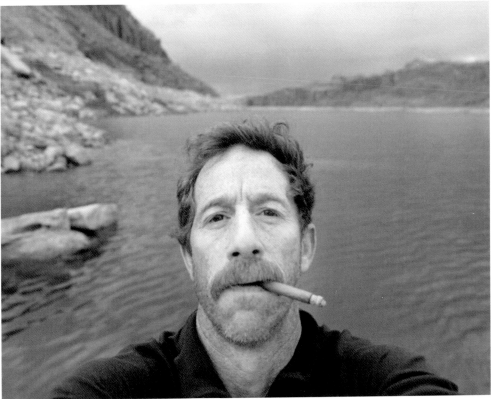

### Bob Kolbrener (1942)

Three decades after a career spent ducking and dodging and effectively putting his camera into the play with the St. Louis Cardinals, he did the same thing with an imposing wave along the Central Coast. Rather than trying to record "Rock Covers Paper," the fleeting California version of a Hokusai wave from a cliff 30 feet overhead, he climbed down under it, giving himself little more than a second to photograph the drama before the wave hit the photographer and the camera, literally flooding his perspective. He has an eye for potential; his camera has vision. He is Bob Kolbrener, and the camera is an 8-by-10 Sinar. Together, they create art. (Courtesy of Bob Kolbrener.)

### Joanna Austen (1915–1999)

Photographer Joanna Austen used to slip out of her Carmel cabin into the early hours of the day to join Ansel Adams, Edward Weston, and whoever else was willing to get up in time to take advantage of the clear light. Yet her favorite moments were when the fog rolled in, laying a gauzy filter across the afternoon landscape, or when a winter storm began to brew off shore. Then she would shrug into her slicker, stamp into her galoshes, and run out into the rain to see if she could capture the temper of the tides. (Courtesy of Kris Swanson.)

### Miller Outcalt (1914–2004)

He was the kind of guy one would never read about. Born and raised in Ohio, Miller Outcalt eked out a degree from the University of Cincinnati Law School but never practiced law. Upon graduation, he left his law degree behind and came out to California to start over. Outcalt ultimately made his money selling photography supplies. He made his mark with macrophotography, an abstract expression of color and form. But he made the news with his generosity. The year before his passing, Outcalt gave $1 million to the Carmel Foundation, dedicated to the wellbeing of senior citizens. His gift followed more than $500,000 in donations to Community Church of the Monterey Peninsula and the Monterey Museum of Art, as well as other random acts of finance. (Courtesy of the Carmel Foundation.)

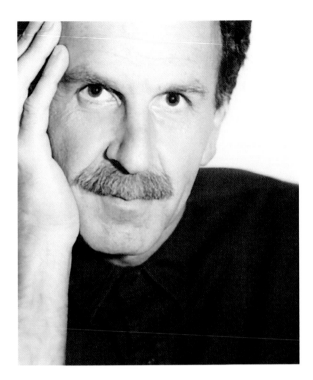

**Kenneth Gregg (1947)**
He found her by accident, if anything ever is. The grieving angel Kenneth Gregg photographed in an Italian graveyard became the epitome of "Pathos," his tragic Italian statuary that became one of his most renowned series. Originally a commercial photographer, traveling the world on assignment, Gregg began to feel his photographs were attractive but inanimate. So, in 1977, he retired his commercial camera and moved to Carmel in search of the soul in himself and his subjects. He found both. (Courtesy of Kenneth Gregg.)

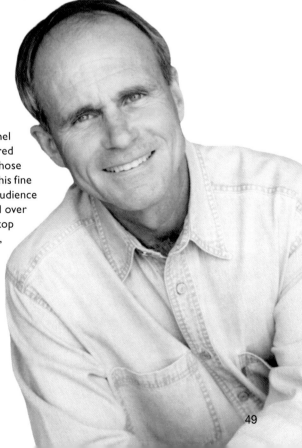

**Douglas Steakley (1944)**
When Douglas Steakley photographed the Carmel Mission at night, it was not the structure he captured but the reverence aglow in the elderly church, whose viewers understood they had been blessed. With his fine art photography, it is not the scene that stirs his audience but what he makes of it. Steakley has ventured all over the world, from the mountains of Peru to the top of Kilimanjaro, through the villages of Mexico, the reaches of Southeast Asia, the splendor of Bali, and the clear light of Carmel. Where he focuses his lens is the aspect of the scene, the setting, the subject that grabs his attention. The award-winning photographer is a master at composing clean, simple, straightforward images removed of anything that might detract from the emotion he chooses to express in the image. (Courtesy of Douglas Steakley.)

### Jean Brenner (1935)

As she watched the landscape materialize from her window seat, she realized, in mere moments, she must disappear. She took a last sip of soda, closed her novel, and stretched out her back, enjoying the weightless freedom of unfettered shoulders. Before her foot ever touched Saudi soil, she shrouded her face, her hair, her presence. Loathe to retreat beneath the suffocating folds of the scratchy black fabric, she pulled the dreaded abaya from her satchel, took a deep breath, and obliterated everything but her feelings. Photographer Jean Brenner was just visiting.

One might assume she went to take photographs. But her images are merely a record of the experiences she sought and found in the faces of those who live within a culture so far and away from her own. She always asks. And they often say no. But when they offer a nod or a smile, she honors them and educates her audience with portraits of their souls. (Courtesy of Jean Brenner.)

### Rahel Rosenzweig (1957)

She is a photographer whose images represent life as she sees it and as she values it, from her Jungian perspective of a collective unconscious and shared sense of reality. Rahel Rosenzweig's view is the sum of her experiences in various settings, beginning in New York where she was born, layered with an upbringing just outside of Chicago. In moving to the Monterey Peninsula, she compared her immediate sense of home to the "heaven on earth." (Courtesy of *The Carmel Pine Cone*.)

## Tom O'Neal (1942)

Rock 'n' roll defined and dominated an era during the mid-1960s to mid-1970s, creating a counterculture that painted San Francisco psychedelic and gave Los Angeles a reason to sing. That was when a young photographer, with just two cameras and three lenses, could climb on stage to photograph the sweat. Photographer Tom Gundelfinger O'Neal came to Carmel in 1965 to visit a friend for two weeks but stayed long enough to catch the first Monterey International Pop Festival in June 1967. The festival reportedly hosted the premier American appearances by Jimi Hendrix, the Who, and Janis Joplin. The now world-famous O'Neal was there and so was his camera. (Courtesy of Tom O'Neal.)

## Randy Tunnell (1952)

One of Randy Tunnell's great joys as a portrait photographer is that he gets to meet interesting people in interesting places he otherwise would not have been invited. In back rooms and board rooms, green rooms and dark rooms, he gets up really close to the power and creativity he captures in his environmental portraiture. Randy Tunnell started out wanting to be rock 'n' roll photographer Tom O'Neal. So did a lot of people, and they were not all photographers. Then Tunnell came upon the compelling imagery by portraitist Annie Leibovitz, who critiqued his college senior project. Working first as a newspaper photographer, shooting sports figures, celebrities, and hard-news subjects, Tunnell's career took a twist when he was hired to photograph O'Neal. Tunnell found him a kind, talented, and generous individual, which is exactly what people say of Tunnell. (Courtesy of Randy Tunnell.)

**Rachael Short (1982)**

In fall 2010, Carmel photographer Rachael Short celebrated the first anniversary of her Carmel gallery, Exposed. She stood at the wedding of her best friend and photographed one of her last weddings of the season. Then, the avid athlete purchased a season ski pass. That night, Short and three friends climbed into a friend's car to attend a Halloween party. Short was still trying to fish her seatbelt out of the crevice in the backseat when the driver lost control of the car. She heard the brakes screech. She remembers the impact, remembers lying across the backseat, remembers looking at her arm, and knowing it could not move. But there was no bleeding and no pain. No one else was hurt. She remembers asking the helicopter attendants if she might have a drink of water. They told her no. She decided it would be best to close her eyes. Short received her first sip of water 18 days later.

Classified as a quadriplegic, Short could move her head, neck, and shoulders, but nothing below her elbows or chest. The hands that released a shutter, grasped a ski pole, and braided her hair sat soft and pale, atrophied in her lap. But Short never bought into her diagnosis. A year later, she started taking photographs with her smartphone, and has since been experimenting with platinum printing and how to incorporate her traditional fine art black-and-white photography into what her limited hand function will allow. In 2014, she celebrated the five-year anniversary of her gallery and joined the board of the Center for Photographic Art, part of the next generation of local photographers. (Courtesy of Tom O'Neal.)

# CHAPTER FOUR

# The Architects

Carmel-by-the-Sea is an anachronism. Tucked into the bluffs above a craggy coast softened by a swath of white sand, the historic village, like the fabled Brigadoon, disappears into the evening fog to reawaken, seemingly unchanged, to live out its next day. As such, it will live forever. In the 100 years since its incorporation, Carmel residents have worked very hard to preserve it, investing considerable energy and attention in appreciating and protecting their inheritance.

Loyal custodians of the coastline that frames their town also guard the foundation on which it was built—the cottage architecture in which Carmel was settled and that anchors the modern-day community to its heritage. These are the residents who do their best to maintain the face of Carmel while modifying the interiors to suit their contemporary lives.

"These cottages are a significant part of our Carmel history," said the late Enid Sales, executive director of the Carmel Preservation Foundation, who came to Carmel in 1933. "This has been a very important little city since it began in the early 20th century. This small center of artistic and intellectual community is known all over the world for its unique architecture. We have a responsibility to the heritage and to the legacy of Carmel to preserve its character." Yet even Sales, who lived in a cottage built by early Carmel mayor Perry Newberry, enjoyed new plumbing, electrical wiring, and a contemporary kitchen. "It is quite possible," she said, "to modernize a small cottage without losing its character or historical merit. As long as it is restored with integrity, it becomes a livable artifact."

A century ago, little about the Carmel landscape rivaled the appeal of the magnificent seascape. That is, until 17-year-old Michael J. Murphy came to Carmel to build homes. He built his first home around the tent in which his family was living. Two decades later, Hugh Comstock built his bride a dollhouse. Neither an architect nor a carpenter, Comstock fashioned a 400-square-foot cottage so quaint, so endearing, and so different from Murphy's board-and-batten summer homes that the demand for Comstock homes "for under $100" made the man a legend.

Nearly 100 years later, in 1998, Coldwell Banker Del Monte Realty brokers Tim Allen and Greg Linder resold an original Murphy-built home along coastal Carmel for $8,250,000. Clients paid handsomely for the updated home, but their principal purchase was the beautiful view of that arc of white sand framing Carmel Bay.

No matter how lovely the facade, how manicured the grounds, or how high-tech the kitchen, most houses are not going to achieve the multimillion-dollar prices garnered by properties in the tonier coastal reaches of Carmel. It is not the home improvements that command these prices; it is the location. As early landscape painter Francis McComas said, "The greatest meeting of land and water in the world" gives value to the property and precedence to the view. It is all about location, location, location. Herewith are some of the people who have made the most of this location.

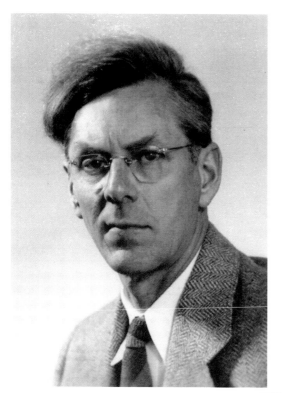

### Hugh Comstock (1897–1950)

In 1924, Carmel resident Hugh Comstock built his wife a dollhouse. Married to Mayotta Brown, creator of the Otsy-Totsy dolls, which warranted a "fairy house in the woods" for display, Comstock created what became Dollhouse Tudor. The Dutch-door, Carmel-stone fireplace, scattered shingles, and rough-framed windows of what is now called Hansel House became signature embellishments of Comstock's many cottages that followed. The only quaint commercial structure he designed was likely his most legendary, the Tuck Box, which still serves tea. (Courtesy of Harrison Memorial Library.)

### Olaf Dahlstrand (1916–2014)

The property once housed the old movie theater and soda fountain. Yet in 1959, Carmel architect Olaf Dahlstrand was hired to design the Carmel Plaza shopping center in keeping with the character of Carmel. Dahlstrand, who admired the architectural aesthetic of Frank Lloyd Wright, opted for a modern but modest structure that would not overwhelm the other storefronts on Ocean Avenue. He also applied his appreciation for the character of Carmel in the design of many homes and commercial buildings, among them the Wells Fargo Bank building. A member of the Carmel Art Association, Dahlstrand enjoyed painting and drawing, which led to commissions by other architects. A devoted Carmel resident, he was active in Carmel community affairs, serving nine years on the planning commission and three years on the Carmel City Council. (Courtesy of *The Carmel Pine Cone*.)

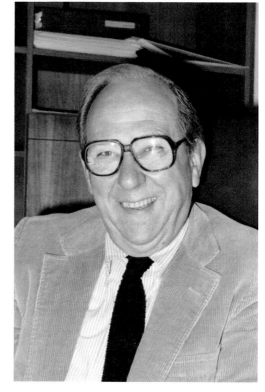

### Frank Lloyd Wright (1867–1959)

In the mist, it looks like the bow of a ship facing a restless sea. Designed by Frank Lloyd Wright and completed in 1948, the Walker House, built overlooking the craggy side of Carmel Beach, is anchored to the community like a sculptural monument to the man. Perhaps its cameo in the 1958 romantic film *A Summer Place* contributes to its cachet. Or maybe it is because the stone structure protruding from the point as if it were a natural part of the seascape is so decidedly Wright, it is as if a part of him is still in town. (Courtesy of the Library of Congress.)

### Mark Mills (1921–2007)

High atop a winding path, architect Mark Mills built his family a home in a rich wood that would darken over time and temperature. Disturbing little as it was built, his design became a testament to his reverence of nature. It was neither the first nor the last house Mills would design for the neighborhood, each bearing the signature of a designer whose aesthetic was influenced by kindred sensibilities to Frank Lloyd Wright. Mills spent four years working at Taliesin West, Wright's legendary winter haven, adopting an appreciation of the effective use of space and a respect for the landscape. Mills went on to work with contractor Miles Bain to build the Walker House in Carmel, a Frank Lloyd Wright design. Upon completion of the project, Mills continued to play out his career in Carmel. (Courtesy of Barbara Mills.)

### Ernest Bixler (1898–1978)

Although his wife, Ruth, was an astrologer, Ernest Bixler was decidedly more grounded. The residential designer-builder came to Carmel from Oakland in 1928 and built his business from the ground up, working as a carpenter for $4 to $6 a day. Yet, by 1965, Bixler had built more than 80 homes in Carmel, among them the stand-out stone structure at the corner of Scenic Road and Martin Way, overlooking Carmel Bay. Bixler's contributions to Carmel extended into community service. He was the postmaster from 1939 to 1942, and he held a seat on the Carmel Planning Commission from 1946 to 1952. Although photographs of the late architect are scarce, his Carmel presence remains prominent in his architecture. (Courtesy of John and Laurel Fosness.)

### James Gordon "Jim" Heisinger (1928–2008)

Just eight years old when his family moved to Carmel, Jim Heisinger grew up climbing coastal trees and cavorting along Carmel Beach, hunting and fishing with his father in Carmel Valley, and acting in the Del Monte Summer Theater. After graduating from Carmel High School and playing football for what are now Hartnell College and Monterey Peninsula College, Heisinger graduated from Brigham Young University with degrees in history and art before coming back to Carmel to pursue architecture. His enduring mid-century designs throughout the city reflect a sincere understanding of the landscape, culture, and character of Carmel. (Courtesy of James G. Heisinger Jr.)

**Robert Stanton (1900–1983)**
There is a reason the highest honor bestowed by the Monterey Bay Chapter of the American Institute of Architects is called the Robert Stanton Award. A student of architecture at UC Berkeley, Stanton worked for architect Wallace Neff in Pasadena, earning his architectural and real estate licenses before moving to Pebble Beach in 1935 and establishing an office in the old Hotel Del Monte. Stanton made a name for himself through his architectural designs, which included the first prefabricated house, the Presidio of Monterey, Carmel's Normandy Inn, the restoration of Church of the Wayfarer in Carmel, and many other historic sites, hospitals, and schools. Stanton was equally renowned for his philanthropic largesse. (Courtesy of Harrison Memorial Library.)

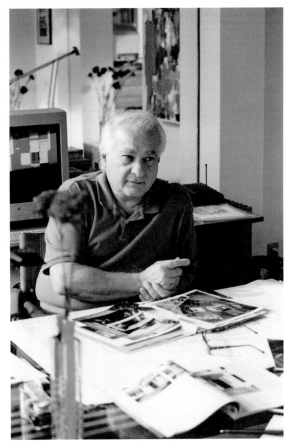

**John Thodos (1934–2009)**
To John Thodos, the idea of copying something was repugnant. As a result, he had a recognizable style. People did not ask for something English or Tuscan or classic or contemporary; they asked for a Thodos. He also believed his work should speak for itself. His voice was strong but not loud, encouraging a dialogue between structure and setting. He enjoyed an energetic discourse but was comfortable with a break in the conversation, with the silent spaces uncluttered by extraneous expression. Thodos was a modernist, preferring to live in the present, look toward the future, and leave the past where he last saw it. (Courtesy of *The Carmel Pine Cone*.)

### George Brook-Kothlow (1934–2012)

To understand the sensibilities of architect George Brook-Kothlow, take a look at his home. It also explains his architecture. Anchored in a grassy knoll on a ridge overlooking the Carmel Valley, the reclaimed timber structure seems designed by someone loath to be asked indoors.

Brook-Kothlow's philosophy was to express the structure and not hide it within the walls. All of his designs are rigorous exercises in geometry. The challenge was getting them to work. Above all, he was determined his designs remain in harmony with the landscape. (Courtesy of *The Carmel Pine Cone*.)

### Rob Carver (1953)

Impassioned by painting, Rob Carver might have studied art, but he never quite believed he could make a living as an artist. Also intrigued by business and finance, he saw architecture as the alchemy of interests that would sustain him. In 1979, he established his own architectural firm in Carmel, which continues to operate as Studio Carver. Although his architecture tends to dominate his art, he established an art studio down the coast, where he always intends to devote more time to his painting. (Courtesy of Rob Carver.)

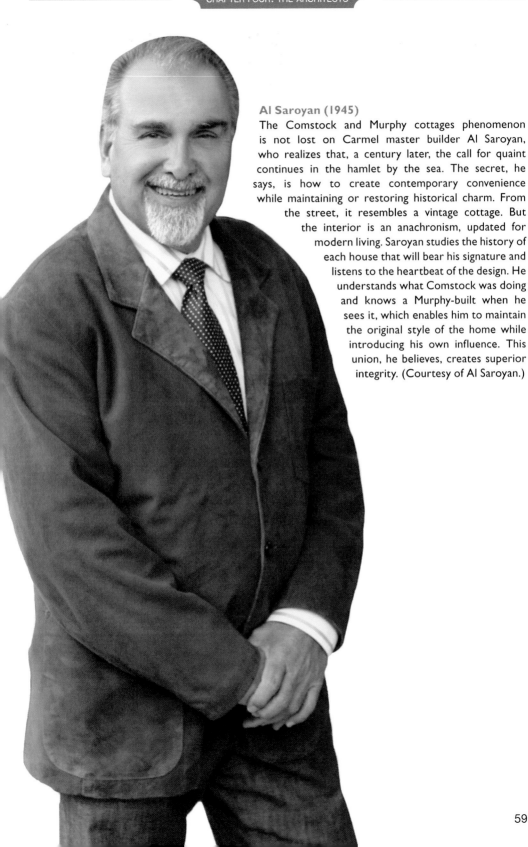

### Al Saroyan (1945)

The Comstock and Murphy cottages phenomenon is not lost on Carmel master builder Al Saroyan, who realizes that, a century later, the call for quaint continues in the hamlet by the sea. The secret, he says, is how to create contemporary convenience while maintaining or restoring historical charm. From the street, it resembles a vintage cottage. But the interior is an anachronism, updated for modern living. Saroyan studies the history of each house that will bear his signature and listens to the heartbeat of the design. He understands what Comstock was doing and knows a Murphy-built when he sees it, which enables him to maintain the original style of the home while introducing his own influence. This union, he believes, creates superior integrity. (Courtesy of Al Saroyan.)

**Mary Ann Schicketanz (1956)**
Once her dancing career was cut short at the age of 18, Mary Ann Schicketanz went on to study architecture in Vienna and Stuttgart. After receiving her master's degree in architectural engineering from the TU Stuttgart in Germany, she worked on a large hotel and housing projects in the historical context of European cities. Once settled in Carmel, she took a special interest in the city's eclectic architectural history, specifically in what she considered its underappreciated modernism.

Schicketanz moved to Carmel with her family in 1987. Together, she and Enid Sales founded the Carmel Preservation Association, where she served as board member and secretary. For 25 years, she practiced as a partner in the former firm Carver + Schicketanz, now Studio Schicketanz, where she has created an impressive body of work and has helped carry on her Austrian lineage of Neutra and Schindler within the context of Carmel. (Courtesy of Mary Ann Schicketanz.)

# CHAPTER FIVE

# The Performers

Many would consider the moment conductor Paul Goodwin lifts his baton to commence the Bach Cantata on opening night at Sunset Center the beginning of the annual Carmel Bach Festival. But for many, it marks the end, the culmination of a year's efforts to bring it to fruition, backed by more than 75 years of posterity and preparation.

The Carmel Bach Festival began in 1935 (put on pause during the war years), when Dene Denny and Hazel Watrous, who had established the Carmel Music Society 10 years before, founded the festival in an effort to further ignite a culture and community of music and theater in their artistic enclave by the sea.

To this day, the festival continues to grow and thrive, not only because Bach endures, but also because a dedicated staff, more than 100 musicians, and scores of volunteers collaborate to make it interesting, evocative, and relevant to an increasingly diverse audience.

The Bach Festival is not the only event of stage and sound that takes place at Sunset Center. Built as Sunset School in 1926, the campus added an auditorium in 1931, recognized as the finest assembly hall in the region. Some 30 years later, in 1963, the City of Carmel purchased the property and renamed it Sunset Community and Cultural Center. In 2003, a $21.4-million renovation was completed on the Sunset Center, which reopened with the Carmel Bach Festival and continues with a premier performing-arts schedule of music, dance, comedy, and drama.

A block from Sunset Center, nestled among the pines, is the Forest Theater. The storied outdoor venue dates back to 1908 when poet-dramatist Herbert Heron and several of his bohemian cohorts, among them author Mary Austin, came up with the idea for a theater in the wild and formed the Forest Theater Society. The Carmel Land Development Company, which owned most of the city at the time, granted the society a rent-free, long-term lease and financed the construction of the stage and wood benches to seat 600.

In the absence of street lights, stars twinkle like spotlights through the canopy of redwoods. In the absence of stars, when fog filters through the trees, shrouding the sky, blazing fire pits light the stage and warm the audience, their sparks crackling and spitting into the darkness. Audiences wrapped in blankets and seated upon cushions brought from home, nosh on their evening picnics while waiting to watch live theater performances of *Twelfth Night*, *A Midsummer's Night Dream*, *Peter Pan*, *Beauty and the Beast*, *Cats*, *The Wizard of Oz*, and other legendary musicals and plays. In the summer, movies nights are added.

Among a large and vibrant community of actors and musicians, many still direct or perform at Sunset Center, the Forest Theater, the Carl Cherry Center, and the Golden Bough Playhouse. Other dramatic artists have come to Carmel to slip into anonymity by the sea. The curtain rises on some of them in the following pages so they may take their bow.

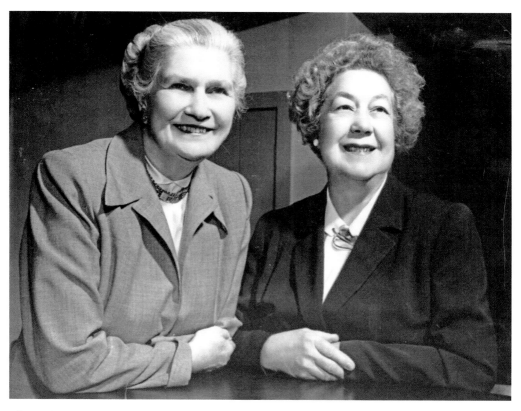

**Dene Denny (1885–1959) and Hazel Watrous (1884–1954)**
Depression-era women Dene Denny and Hazel Watrous were musicians who believed Carmel-by-the-Sea could become the "epicenter of world-class music." The pair created a culture of music and art by hosting concerts at a pair of grand pianos in Harmony House, their Carmel home. They founded the Carmel Music Society in 1927 and the Carmel Bach Festival in 1935. They ran a major concert series in the San Jose Civic Auditorium and an avant-garde series in Carmel. They founded California's First Theater in Monterey, which produced melodramas. And they funded their endeavors by building 36 cottages in Carmel. Surely they would be thrilled to know they were correct. (Courtesy of David Gordon.)

**David Gordon (1947)**
After more than 25 years with the Carmel Bach Festival, dramaturge David Gordon still lights up when he discusses Bach and seeks to ignite the same excitement in his audience. Musical talent courses through the musician and renowned classical music historian like counterpoint, creating a harmonious diversity of opportunity and experience throughout his career. He has performed at least 60 principal roles with, among others, the Metropolitan Opera, San Francisco Opera, Chicago Lyric Opera, Houston Grand Opera, Washington Opera, and the Hamburg Staatsoper. He has sung with nearly every leading North American symphony orchestra and with other prestigious orchestras and festivals on four continents. He has sung at every major North American Bach Festival as well as Bach festivals in Europe, South America, and Japan. His passion remains in Carmel. (Courtesy of David Gordon.)

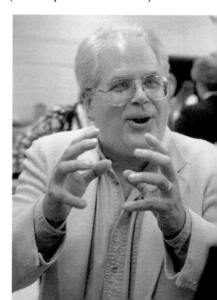

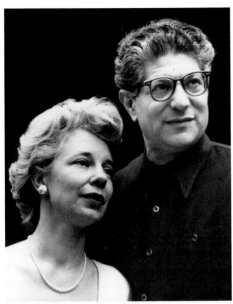

Sandor Salgo (1909–2007)
Hired in 1956 as music director of the Carmel Bach Festival, Hungarian-born violinist Sandor Salgo, pictured here with his wife, Priscilla, made considerable contributions to the festival. In his mission to professionalize the ensemble, he established a fee for many orchestra musicians in addition to housing and travel costs. He also created the Festival Chorale, composed of professional singers from Los Angeles. Although there had been no public concerts at the Carmel Mission Basilica since the 1940s, in 1962, Salgo convinced the diocese to allow Bach Festival concerts in the hallowed space. By the end of his 36-year tenure with the festival, his candlelit Mission Concerts had become legendary. (Courtesy of *The Carmel Pine Cone*.)

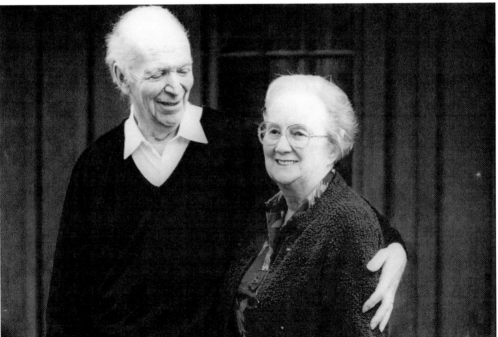

Bruce Grimes (1912–1995)
Although he realized he was singing for Hitler, a kind of bliss overtook the fear of a young singer performing the greatest operas ever written. A student of sciences at Northwestern University in Chicago, the young basso cantante studied voice with Adolf Muhlmann at the Metropolitan Opera before moving to Germany to sing at the Berlin Staatsoper. From the stage, Grimes could see the curtain move across the boxed seat reserved for the Führer. In 1955, Grimes moved to Carmel with his wife, Olive, an organist. The couple bought the Seven Seas gift shop on Dolores Street, but he never stopped singing, gracing the Carmel Bach Festival stage for the next 23 years. (Courtesy of Alan McEwan.)

### Bruno Weil (1949)

In his first season as music director and principal conductor of the Carmel Bach Festival in 1992, it was immediately apparent that Bruno Weil would develop and refine the festival's 18th-century style. He introduced members of the new generation of baroque instrumental specialists to the orchestra, bringing a "fresh, stylish texture" to the music. In 1993, the German-born symphonic conductor brought in renowned baroque violinist Elizabeth Wallfisch as concertmaster, and together they elevated string playing to world-class standards. During Weil's 18-year tenure, the Bach Festival Orchestra, according to dramaturge David Gordon, developed a reputation as an ensemble that could play brilliantly on 18th-century instruments as well as modern 19th- and 20th-century versions. (Courtesy of *The Carmel Pine Cone*.)

### Paul Goodwin (1956)

Considered one of Europe's most creative conductors, Paul Goodwin, whose life is based in London, England, is the fourth maestro to lift his baton in the near 80-year history of the Carmel Bach Festival. The festival's principal conductor and art director spent 16 years performing as a professional oboist for some of the greatest orchestras and in many of the finest concert halls in the world. Yet, after receiving offers for several prestigious conducting engagements, he set down his oboe and picked up the baton. (Courtesy of the Carmel Bach Festival.)

### Linda Watson (1960)

World-renowned, Grammy-nominated Wagnerian soprano Linda Watson has traveled all over the world yet sends her roots deep into Carmel. The fifth-generation northern Californian lives in Vienna, Austria, yet returns annually to her family home in Carmel-by-the-Sea. In 1997, she was married at Carmel's Church of the Wayfarer, where her grandmother worshipped. In 2011, she performed a holiday concert benefiting young artists at Hidden Valley Music Seminars in Carmel Valley. Wherever she is in the world, Watson appreciates the place where reminiscences come easily in a community that remains, largely unchanged, awaiting her homecoming. (Courtesy of Linda Watson.)

### Stephen Moorer (1961)

The Carmel-based stage actor, director, and producer is a creative force in theater arts on the Peninsula. In 1982, he established GroveMont Theater, and after acquiring Carmel's legendary Golden Bough Playhouse in 1994, he renamed it the Pacific Repertory Theater. Moorer also founded the Carmel Shakespeare Festival, Monterey Bay TheatreFest, and the Actors-in-the-Adobes programs. He cofounded the Monterey County Theatre Alliance, is a founding board member of the Monterey Opera Association, cofounded the Forest Theater Foundation, and serves as a founding board member of Carmel Performing Arts Festival. Born in Southern California, at 11, Moorer moved with his family to Carmel, where he attended school and studied theater at Carmel's Children's Experimental Theatre. (Courtesy of Pacific Repertory Theater.)

## Stephen Tosh (1949)

If one has heard original music performed on the Monterey Peninsula, there is a good chance it was composed by Stephen Tosh. Born and raised in Los Angeles, the innovative composer began writing music at age three and has spent his life creating symphonies, concertos, chamber works, operas, ballets, and cantatas. His music has premiered, among others, in the Monterey String Quartet, Ensemble Monterey, Youth Music Monterey, and the Monterey Peninsula College String Ensemble and Concert Band. (Courtesy of *The Carmel Pine Cone*.)

## Walt deFaria (1926)

Walt deFaria was seven years old when he became interested in theater, which is the age of many of the children he has been directing at Carmel's Forest Theater for more than 16 years. Following a prestigious career in motion pictures and television, in which he served as producer or executive producer for *The Mouse and His Child* and each production of *The Borrowers*, including *The Secret World of Arrietta*, deFaria moved to Carmel in 1988 and has since devoted his life to family theater. In addition to directing *Peter Pan* and *The Wizard of Oz*, among many others, he has written 10 young people's musical comedies with composer Stephen Tosh for the local Pacific Repertory Theater. (Courtesy of Walt deFaria.)

**Dale Lefler (1914–2011)**
Dale Lefler was born to dance in a golden era for Hollywood hoofers. When he danced in *Baby It's Cold Outside*, André Previn was the rehearsal pianist. For MGM's *Girl Crazy*, with Mickey Rooney and Judy Garland, Busby Berkeley choreographed the routines. Lefler also danced his way through Esther Williams extravaganzas. His final film was Warner Bros.' *Lucky Me* with Doris Day, the last of three films he made with the iconic Carmel character before he abandoned Hollywood in 1953 and moved to the Carmel area himself. At 90, Lefler took the curtain one more time at Carmel's legendary Golden Bough Theater to teach a child how to hoof it in *Kid Millionaire* by director, producer, and writer Walt deFaria and composer Stephen Tosh. (Courtesy of *The Carmel Pine Cone*.)

**Taelen Thomas (1944)**
Audiences can count on a multisensory experience when poet and orator Taelen Thomas, a local performer particularly gifted with the meter and measure of words, stages personifications of historical figures. Considerable research, character costuming, and a booming voice add profundity to each party as Thomas delivers his dramatic monologues, channeling his subjects with such accuracy and nuance; it is as if he has returned Robinson Jeffers, Mark Twain, Jack London, and John Steinbeck to town, if only for the evening. (Courtesy of Taelen Thomas.)

**Sandy Shore (1963)**
At 31, Sandy Shore took a gamble. With a history in suave radio and smooth jazz that already spanned 16 years, she decided to bring the sound alive on the Monterey Peninsula. For a decade, Sandy Shore Productions filled venues by the bay with capacity crowds eager to groove to that deep mix of jazz, R&B, and pop with world rhythms through the sounds of Tony Bennett, Diana Krall, Kenny Loggins, Tower of Power, Fourplay, Dave Koz, and Bobby Caldwell. Shore started her radio career on Cannery Row at 15 and eventually worked the airwaves in Los Angeles and San Francisco. Today she is a global music innovator and internet radio pioneer, having started the world's first smooth jazz radio station in 2000 with artist, musician, and fellow innovator Donna Phillips. (Courtesy of Sandy Shore.)

**Layne Littlepage (1950)**
Carmel native Layne Littlepage, a trained violinist, left the Peninsula to study acting at San Francisco State before moving to New York to pursue a singing career in classical and operatic music, as well as standards from the Great American Songbook. Having sung in capital cities throughout the world, the soprano returned to her roots, where she teaches voice privately and at Santa Catalina School. Her singing career continues to take her around the world, but she always comes home to Carmel. (Courtesy of *The Carmel Pine Cone*.)

**Dennis Murphy (1957)**
Bassist Dennis Murphy has played with the Greg Khin Band, Kenny Rankin, Maria Muldaur, and Acoustic Alchemy, has performed on more than 30 albums, and continues to perform with the Dennis Murphy Band. In 2010, he opened the Dennis Murphy School of Music on the Peninsula. Responding to budget cuts in public school art programs, the three-time Grammy nominee established his school to ensure music education for all ages, as he believes students who have music as part of their learning process have an advantage in an academic setting. (Courtesy of Dennis Murphy.)

**Kenny Stahl (1944)**
Playing the flute well is like a perfect, passionate kiss. When jazz flutist Kenny Stahl brings the flute to his lips, a smooth, seductive sound rolls through the pipe, and all is well with the world. Ubiquitous on the Monterey Peninsula, Stahl has performed solo, in bands, and with symphonies in various venues. A musician who gives wholeheartedly to his community, he often creates the mood at charitable events. A seasoned recording artist, Stahl's sound has influenced numerous CDs, plus his own recordings, *Kenny's From Heaven*, *Scentuality*, and *Mpingo*. (Courtesy of *The Carmel Pine Cone*.)

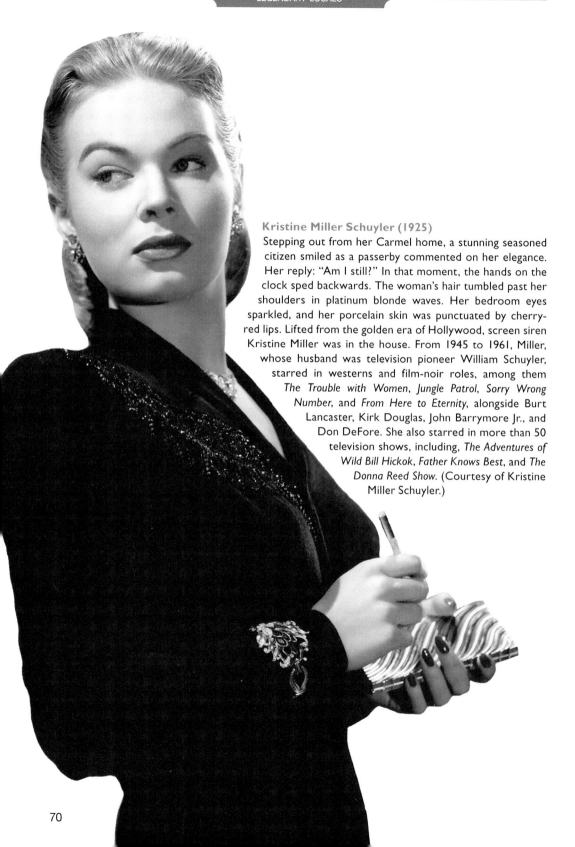

### Kristine Miller Schuyler (1925)

Stepping out from her Carmel home, a stunning seasoned citizen smiled as a passerby commented on her elegance. Her reply: "Am I still?" In that moment, the hands on the clock sped backwards. The woman's hair tumbled past her shoulders in platinum blonde waves. Her bedroom eyes sparkled, and her porcelain skin was punctuated by cherry-red lips. Lifted from the golden era of Hollywood, screen siren Kristine Miller was in the house. From 1945 to 1961, Miller, whose husband was television pioneer William Schuyler, starred in westerns and film-noir roles, among them *The Trouble with Women, Jungle Patrol, Sorry Wrong Number*, and *From Here to Eternity*, alongside Burt Lancaster, Kirk Douglas, John Barrymore Jr., and Don DeFore. She also starred in more than 50 television shows, including, *The Adventures of Wild Bill Hickok, Father Knows Best*, and *The Donna Reed Show*. (Courtesy of Kristine Miller Schuyler.)

# CHAPTER SIX

# The Mayors and Movers

Back in the day, one could see the ocean from just about anywhere. The homes were no higher than a dollhouse, and redwood and cypress seedlings had just been planted in the sandy slopes that rolled down to the sea. At the turn of the last century, Carmel was just a child, and people had only just begun to come out to play. Frank Devendorf and Frank Powers had formed the Carmel Development Company to attract artists, writers, professors, and poets to their bohemian retreat by the sea.

With the help of an earthquake that shook the artists out of the City, the construction of a highway up and over the hill, and a couple of religious retreats, Carmel-by-the-Sea, that one-mile stretch rising above a reprieve in the craggy coastline in the form of an arc of white sand became a destination, a haven, and, to some, a home.

A century later, the city by the sea is an evergreen forest whose houses are still in close quarters, but many have added a second story to secure the view. The place has more tourists than townspeople and a plethora of second homes that sit, like an abandoned bucket at the beach, waiting. The main thoroughfare, once a dirt road called Main Street, was paved and named after the ocean it spills into.

Although Carmel has been hand-carried into the current century, it appears, due to the forces of nature and a fiercely protective population, remarkably unchanged by time. And the people who live here work hard to keep it that way. Enid Sales devoted her seasoned years to preserving the heritage of Carmel through its architecture. At 86, Carolina Bayne stood outside the Carmel Post Office to garner 549 signatures to petition the removal of a controversial city administrator, and succeeded. Shopkeeper Paula Hazdovac served more than 18 years on the city council to protect Carmel, so others could enjoy what she did, growing up.

To some, the town is an anachronism—a village out of time with its cobbled walks and alleyways, thatched-roof houses, quaint cafés, and a city hall that looks like it might be made of gingerbread. Yet Carmel also is a thriving miniature metropolis, with an international menu, a world-class cultural venue, and a roster of renowned festivals and events. It is a town that continues to evolve, a place with a culture attracting a mature audience, while its new nightlife has caught the attention of a hip young generation. Jason Burnett, current mayor of the city by the sea, is still in his 30s. Presented here are some of the mayors and other movers who have worked to preserve the past while protecting the future of Carmel.

Carolina Bayne (1927)

Carolina Bayne had had enough. One month before her 87th birthday, she took on city hall and won. But for Bayne, it was not about winning; it was about protecting, promoting, and preserving her beloved community in Carmel-by-the-Sea. Although she stood in front of the Carmel Post Office speaking to passersby about the injustices she perceived in the behavior of a city official, she is the first to say she did not act alone. She gathered 549 signatures in 10 days in support of removing him from office.

Bayne came to Carmel in 1972 with her husband and three children and moved into a 1901 cottage by the sea, where she lives, in an updated version, today. A registered nurse, she worked at Community Hospital of the Monterey Peninsula for 21 years. Shifting from medical care to community activism, Bayne established a master-gardener program designed to teach the community how to thrive in the landscape. She also instigated a campaign to implement mail delivery to the Carmel-by-the-Sea community, a neighborhood with names on the gates but no house numbers. At 87, she is likely just getting started. (Courtesy of Carolina Bayne.)

### Maggie Hardy (1948)

Maggie Hardy used to say, if she could live anywhere in the world, it would be where the environment mattered, and the city had a sense of community. In 1992, she left her life in Los Angeles and came to Carmel, where she promptly took a seat on the planning commission. Raised in public service, Hardy found Carmel a community where everyone seems to care, get involved, clean up beaches, host fundraisers, conserve cottages, and rescue dogs. The artist in her paints, sketches, sculpts, and lays tile. The community and environmental advocate has co-run campaigns for the mayor. The writer, a founding member of the Carmel Writers Workshop, turns phrases into pure poetry. (Courtesy of Maggie Hardy.)

### Karin Strasser Kauffman (1941) and Peggy Downes Baskin (1930)

Karin Strasser Kauffman (left) and Peggy Downes Baskin (right) do not believe women can be all things and do all things or that they even want to. Strasser Kauffman, who taught political science and women's studies for more than 20 years before serving two terms as Monterey County supervisor, and Downes Baskin, who coauthored *The New Older Woman* and taught politics and women's studies for more than 30 years, wrote what lies *Beyond Superwoman*. Published by Carmel Publishing Company, their book entertains like a novel and guides like a text, revealing how 25 female CEOs can bake a cake, market a cake, serve a cake, and eat a cake—but not all at once. (Courtesy of Peggy Downes Baskin.)

### Paula Hazdovac (1955)

Born and raised in Carmel, Paula Hazdovac loved growing up in what she calls a fairytale land by the sea. After graduating from San Jose State with a degree in social sciences, she came back to Carmel to find Clint Eastwood running for mayor. A lot of people suddenly became interested in Carmel politics, and she was one of them. Hazdovac, who runs Two Sisters Designs, a boutique she established in 1994 with her sister Pat Hazdovac, sat on the city council for almost 19 years, the longest tenure in Carmel history to date. (Courtesy of Paula Hazdovac.)

### Sue McCloud (1934)

Former mayor Sue McCloud was eight when she moved with her family to Carmel-by-the-Sea. After commencing from Carmel High School, followed by Stanford University with a degree in political science, she went to the Switzerland Graduate Institute of International Studies. Her sister assumed she went there to ski, but apparently she learned enough to spend the next 31 years in a high-ranking position with the CIA before returning to the political arena of her beloved Carmel-by-the-Sea. During her unprecedented six-term tenure as mayor, McCloud was dedicated to the protection, preservation, and progress of Carmel. She still lives in her parents' home, which she says she "gutted to the studs" and remodeled to make it her own. (Courtesy of Sue McCloud.)

**Bill Doolittle (1940)**
Carmel without Bill and Nancy Doolittle would be like Bedford Falls without George Bailey. Without their commitment to the community, landscape, and culture of Carmel, the Sunset Center of performing arts would not have received its $21-million remodel. There would be no Mission Trails Park, a nature preserve with five miles of hiking trails. The pristine landscape might have disappeared under development, arts organizations might have gone without creative expression, and numerous nonprofits might have disappeared without their leadership and largesse. (Courtesy of *The Carmel Pine Cone*.)

**Ryan Zen Lama (1978)**
Ryan Zen Lama is a hunter-gatherer of people, opportunities, and talent. The self-proclaimed "Wanna-Be Ninja" intent upon living the best life every day is also intent upon creating a sense of community among the young professionals in the area. To that end, he founded *831* magazine, a contemporary quarterly publication that creates a forum to connect the artists, athletes, foodies, fashionistas, bohemians, and businesspeople of the community. While his writers are giving voice to a bright, edgy generation, Lama is out hosting the activities and events that create the scene worth writing about. This social entrepreneur is a connector and collaborator recognized for his largesse in the community, particularly in charitable causes. (Courtesy of Ryan Zen Lama.)

### Sam Farr (1941)

Congressman Sam Farr, a fifth-generation Californian born in San Francisco on the Fourth of July and raised in Carmel, represents the Central Coast, where he has been a prominent advocate for agriculture, affordable housing, and ocean conservation. A member of Congress since 1993, Farr serves on the House Appropriations Committee, is a member of the Appropriations Subcommittee on Agriculture and the Rural Development and Food and Drug Administration, sits on the Subcommittee on Military Construction and Veterans Affairs, and cochairs several caucuses. Perhaps most important, Farr is a prominent presence in his community and in his family with wife Shary, their daughter, and two grandchildren. (Courtesy of Randy Tunnell.)

### Shary Farr (1946)

She believes end-of-life planning does not make illness or death happen; it just makes things easier on the family. It is a message her grandmother conveyed as she went through her own stages of preparation, and a concept that has fueled Shary Farr's mission to help others. A life-planning specialist married to Congressman Sam Farr, she helps people plan for major life transitions with the belief that this frees them up to live in the moment. In 2008, Farr, who was named one of 10 Outstanding Women in Monterey County in 2002, established Partners for Transitions, which provides planning, guidance, and partnership for aging, illness, and the end of life. (Courtesy of *The Carmel Pine Cone*.)

**Leon Panetta (1938)**
In 1998, former White House chief of staff Leon Panetta and his wife, Sylvia, founded the Leon & Sylvia Panetta Institute for Public Policy, which serves as a "non-partisan center for the study of public policy aimed at helping the country meet the challenges of the 21st century." The center endeavors to equip people with the practical skills of governance and inspire them to a high standard of conduct in public service. Panetta, who graduated magna cum laude with a bachelor's degree and his juris doctorate from Santa Clara University, practiced law in the Monterey firm of Panetta, Thompson & Panetta, and later served as a US representative from California's 16th (now 17th) district from 1977 to 1993. In 1994, he was appointed chief of staff to Pres. Bill Clinton, a position he held until 1997. From 2009 to 2011, Panetta was the director of the Central Intelligence Agency, and from 2011 to 2013 he served as the US secretary of defense. (Courtesy of Randy Tunnell.)

### Edgar Haber (1912–2005)

He thought golf was a sissy game until, at 17, he gave it a shot. By 20, he had won the San Francisco Amateur Golf Championship, which ignited a dream to build his own course. Ed Haber grew up to become the emperor of enterprise, working in a diversity of endeavors. After moving to Carmel in 1947, he founded Carmel Valley's first newspaper, movie theater, and liquor store. Then, in 1964, he realized his dream, developing a golf course across the old Carmel Valley Dairy along the Carmel River. Ultimately, it became what is prized today as the five-star Quail Lodge & Golf Club. Yet Haber is best remembered as a dapper man with a ready smile and by his philanthropic largesse, having donated millions of dollars to local charities. (Courtesy of *The Carmel Pine Cone*.)

### Dennis LeVett (1938)

He was just 21 years old when he started buying real estate in what became Silicon Valley. Dennis LeVett ultimately established Strutz LeVett, which manages commercial and residential properties. President of Carmel Boutique Inns, LeVett purchased the first of several inns in the 1960s, adding, in the mid-1980s, the legendary Cypress Inn, which he co-owns with Doris Day. An active member of his community, he serves on many boards, and champions causes close to Carmel. (Courtesy of *The Carmel Pine Cone*.)

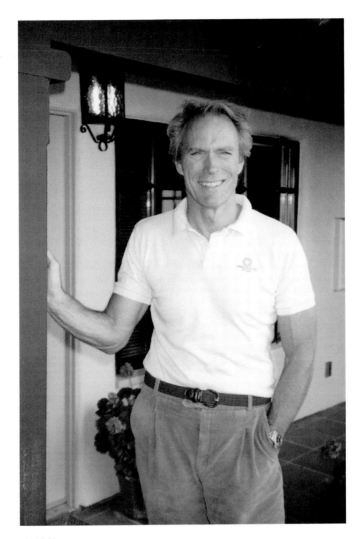

Clint Eastwood (1930)

When guests come to Carmel-by-the-Sea looking for the mayor, they are not always seeking the current office holder. For many, the man perhaps best known as "Dirty Harry" will always be the mayor of Carmel. He is tall and slim, with steely blue eyes that carry intelligence, intention, and mirth. His voice, like a cup of black coffee—hold the sugar, means business. And so does he, which was the reason Clint Eastwood ran for mayor and served a two-year term from 1986 to 1988, during which he reportedly fulfilled all significant campaign promises to himself and his community. To this day, despite some 50 feature films, two of which—*Heartbreak Ridge* and *Bird*—he made while in office, Eastwood's impact on Carmel remains as prominent as his persona.

Perhaps it was his goal and campaign slogan, to "bring the community together." Or maybe it was because he lifted an ordinance, effectively returning ice cream cones to the sidewalks of Carmel. Maybe it was the fact that he shifted zoning laws and made it easier to build or renovate property in this place of historic preservation. He had a tourist parking lot approved and built. He bought and remodeled the legendary Mission Ranch resort and preserved its coastal lagoon landscape on which condominiums were otherwise destined. Further investing in the future of Carmel, he opened a library annex with a dedicated children's library. Clint Eastwood is a man whose reputation precedes him when he walks into a room. But in Carmel, he is just another seat at the bar. (Courtesy of *The Carmel Pine Cone*.)

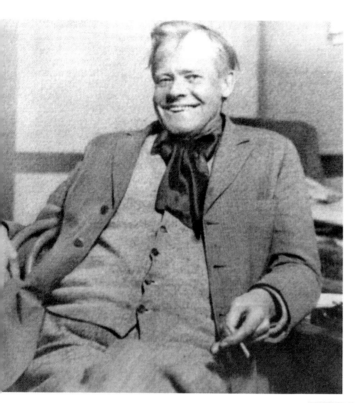

**Perry Newberry (1870–1938)**
Author, artist, actor, and publisher of *The Carmel Pine Cone*, Perry Newberry was one of the most ardent activists for the preservation of what gave Carmel its charm. His mayoral campaign platform said, "If you hope to see Carmel become a city, if you want its growth boosted, if you desire its commercial success, if street lamps on its corners mean happiness to you, if concrete street pavements represent your civic ambitions . . . don't vote for Perry Newberry." Carmel's fifth mayor fought hard to ensure Main Street never got paved. He lost that battle but prevailed with plenty of charm. (Courtesy of Harrison Memorial Library.)

**Herbert Heron (1884–1968)**
Herbert Heron, the eighth mayor of Carmel, was a Shakespearian actor and playwright devoted to the creative culture of Carmel. In the summer of 1910, Heron visited poet George Sterling in Carmel and decided the place needed an outdoor theater in the woods. With the Carmel Development Company's donation of land and construction costs, Heron set the stage at the Forest Theater. In 1925, he built the historic Seven Arts Building, where his studio and bookstore became a gathering place for writers, among them George Sterling and Jack London. The new Carmel Art Association started using the space as an exhibition gallery, as did photographer Edward Weston. In 1976, Barney and Patty Scollan, Heron's granddaughter, opened the Carmel Bay Company in the landmark building, a specialty store that conveys the culture and character of Carmel. (Courtesy of Harrison Memorial Library.)

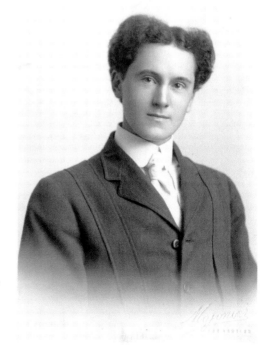

**Barney Laiolo (1909–2000)**
The popular three-term mayor was known for championing progress in Carmel-by-the-Sea in his negotiating the 17-acre gift by Bill Doolittle to create Mission Trails Park and supporting the plan to build the tri-level alpine-like Carmel Plaza shopping center. But he did not get very far when he tried to turn the legendary open-air Forest Theater into a parking lot for city vehicles. (Courtesy of *The Carmel Pine Cone*.)

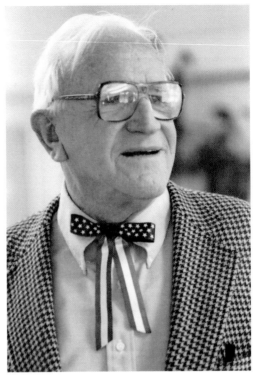

**Gunnar Norberg (1907–1988)**
Carmel mayor Gunnar Norberg was determined to preserve the heritage of his little hamlet by the sea by placing it under a bell jar where he could protect its simple, natural quality of life. A New York journalist, Norberg came to Carmel on vacation with his wife, Barbara, and decided to stay. Norberg opened a travel agency in town, and the couple got into local theater. The more entrenched they became in the community, the more passionate he became about preserving it. Known as the "Conscience of Carmel," Norberg served two terms as city councilman and two terms as mayor, both interspersed by terms of defeat over his outspoken views. (Courtesy of *The Carmel Pine Cone*.)

### Ken White (1934)

As a city council member in the late 1980s, former high school teacher Ken White made a motion to begin remodeling Carmel's Sunset Center Theater, whose poor acoustics, limited sight lines, and small stage were threatening the future of the facility and the culture of Carmel. White served as mayor of Carmel from 1992 to 2000, when a public and private partnership was formed to raise funds to renovate Sunset Center. The following year, construction began on a $21.4-million project, which brought the acoustics of the theater to what conductor Bruno Weil called "a miracle." Following his mayoral terms, the Carmel character could be found in his green vest, helping customers in the hardware department at the legendary Brinton's Remarkable Home & Garden Store. (Courtesy of *The Carmel Pine Cone*.)

### Jason Burnett (1976)

He could have been elected mayor of Carmel-by-the-Sea on his boyish good looks. But, as the founder of Burnett EcoEnergy, a company that structures and secures financing for renewable energy and energy-efficiency projects, Mayor Jason Burnett, elected in 2012 and 2014, looked good to a city intent upon sustaining itself. Believing social change begins at home, he left his position at the US Environmental Protection Agency under the George W. Bush administration, and came back to Carmel to make a difference. His pedigree is equally impressive. The Carmel Valley native and graduate of Stanford University is the son of two marine biologists who helped establish the Monterey Bay Aquarium and grandson of the late David Packard, cofounder of Hewlett-Packard. (Courtesy of Randy Tunnell.)

**Tom Tonkin (1926–2008)**
The kind of vision and devotion that both inspired and directed Tom Tonkin to create Community Hospital of the Monterey Peninsula came from somewhere deep within the man, stirring him as he developed his legendary philosophical and architectural foundations for the hospital on the hill. Tonkin had a keen sense of community and a commitment that everything he did must make a difference in the patient experience at the hospital. He was a visionary who saw exactly where he was headed and a perfectionist, precise in his pursuit of it. (Courtesy of Community Hospital of the Monterey Peninsula.)

**Jay Hudson (1937)**
During a break from his public health and hospital administration graduate program at UC Berkeley, Jay Hudson came to Carmel in 1964 to visit the new Community Hospital of the Monterey Peninsula. As he studied the art and the modern architecture and toured the hospital's unprecedented private rooms, he imagined how rewarding it would be to join their administration. Four years later, he got the opportunity when founding CEO Tom Tonkin hired him as assistant administrator. In 1990, Hudson became CEO of the hospital he so admired. After 10 years of overseeing the development of innovative wellness programs and outpatient services through satellite centers and the installation of the Family Birth Center, Hudson retired but never left, continuing as a volunteer for the hospital he loves. (Courtesy of Community Hospital of the Monterey Peninsula.)

### Carol Hatton (1949–2009)

She went in for a routine mammogram, yet the results changed the course of her life. A decade later, Carol Hatton was still fighting breast cancer, but not just for herself. A longtime Carmel resident, she was as committed to the community's wellbeing as she was to her own. In 2008, she assembled a committee of women who helped her raise $2.5 million to bring digital screening technology to the hospital's breast-care center. And then, she died. She had just turned 60, met her first grandchild, and launched a campaign to raise $500,000 to create a diagnostic fund for women without resources. Her committee went on to realize her goal and put her name on the Carol Hatton Breast Care Center. (Courtesy of Community Hospital of the Monterey Peninsula.)

### Steven Packer (1956)

When Dr. Steven Packer became CEO of Community Hospital of the Monterey Peninsula in 1999, the critical-care pulmonologist, who served as chief of medical staff for two years before he took the helm, saw his role as transforming the hospital to bring it into the modern age of healthcare while developing a culture of accountability, safety, and service. Under his tenure, the hospital has added new wings via the Pavilions Project, built a new intensive care unit, introduced the Ryan Ranch satellite campus, developed the Carol Hatton Breast Care Center, built the Peninsula Wellness Center, and launched Peninsula Primary Care. A man dedicated to his community, he is devoted to his wife, Ann, and their two sons, Joel and Matt, and the active outdoor life they lead. (Courtesy of Community Hospital of the Monterey Peninsula.)

# CHAPTER SEVEN

# The Shopkeepers

In the early 20th century, commercial buildings were constructed as needed—a post office, a mercantile, a bank—along the plank sidewalks that framed an unpaved main street in Carmel-by-the-Sea. More than 100 years later, the seaside village has become a mecca of essentials and ephemera, a destination where shopping is as much an attraction as gallery tours, wine tasting, fine dining, and the beach. Most European villages have a main shopping street where the community convenes, creating the center of town. Styled in a Bavarian tradition, with its gingerbread architecture and floral window boxes, cobbled passages, and cafés, Carmel's shopping street is Ocean Avenue, a once-dirt path the locals fought to protect, believing it would pave its way into a big city.

Today, Ocean Avenue is home to many art galleries, clothing boutiques, cafés and bistros, and specialty and souvenir shops. The butcher is a charcuterie, the drugstore is a pharmacy, and the bank is a financial advisor. But the charm remains, attracting locals and guests to shop their way down the long slope before it reaches the sand and spills into the ocean.

The proximity of this shopping street to the ocean gives it its name, inviting beachcombers to take a break from the sun and wander uptown for a snack or change of scenery. Buyer beware—a century-old covenant still restricts bikini-clad shoppers from surfacing on the streets of Carmel. Other restrictions, such as the bans on high heels and ice cream cones, have been removed—reportedly by Carmel's most famous mayor, Clint Eastwood—evidenced by the high-style shoes in town and the return of gelato and ice cream vendors.

While Ocean Avenue has much to offer, Carmel's shopping district is a matrix of side streets, passages, and courtyards, a walkable labyrinth of discoveries.

Located at the top of Ocean Avenue, Carmel Plaza consumes a city block, housing a specialized shopping center cresting the city by the sea. The community works hard to maintain the Old World–architectural elegance and quaint charm of Carmel, an effort which eschews chain stores and their signature signage or style. Yet Carmel Plaza brings in a blend of boutiques and corporate companies—Tiffany & Co. and Tommy Bahama, Khaki's Men's Clothier of Carmel and Madrigal for Men and Women—whose taste tucks nicely into the shopping sanctuary. The keepers of some of the most enduring shops are featured on these pages.

**Robert Talbott (1905–1986) and Audrey Talbott (1917–2004)**
Packing an East Coast sensibility of classic style paired with culture, Robert and Audrey Talbott came to Carmel Valley in 1950 with their young son, Robb, and began manufacturing hand-sewn silk ties. Now celebrating its 65th anniversary, Robert Talbott fine menswear, women's wear and accessories is a paragon of tradition and value, with a commitment to quality. In an era when a suit and a tie once again has swagger, Robert Talbott still knows how to tie one on. Some say Audrey Talbott's apparel had style. Actually, it was Audrey who had the innate sense of style. Her clothes simply conveyed that. (Courtesy of Robert Talbott)

**May Waldroup (1930)**
Looking to house her Japanese antiques, in 1970, May Waldroup bought a chicken farm with a barn full of books in Carmel Valley and figured she could throw out the books. But she loved the barn and the books, so instead she created the Thunderbird Bookstore. Six years later, following her motto, "Always build what suits the landscape," she designed and built the Barnyard Shopping Village on the landscape of the old Hatton Dairy. Waldroup leased space to boutiques and bistros within the enclave of nine distinct barns, and established the Thunderbird Bookstore as one of the first bookstore cafés. The place became legendary for its bounty of books and homemade popovers served warm by the fire. In 2000, Waldroup wrote about the history of The Thunderbird, the building of the Barnyard, and its tenants, to whom she gave the book as a Christmas present. Copies of *Then and Now: A History of The Thunderbird Bookshop and The Barnyard Shopping Village* are still available at local libraries. (Courtesy of Philip M. Geiger.)

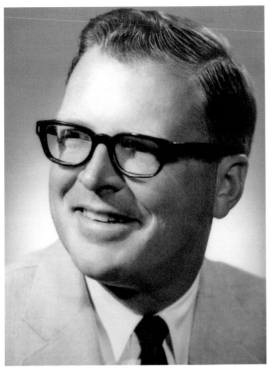

**Homer Hayward (1921–2010)**
He had no intention of going into the family lumber business. His dream was to become an accountant, but then his father died. With little training and less experience, Homer Hayward was crowned head of the family business. He was 24. Yet the guy had grit. Hayward began acquiring lumberyards in Cambria, Seaside, Carmel, Morro Bay, and San Luis Obispo. Under his 48 years of leadership, Hayward Lumber became the leading supplier of lumber and building materials on the Central Coast, and he became one of the more generous philanthropists in town. (Courtesy of *The Carmel Pine Cone.*)

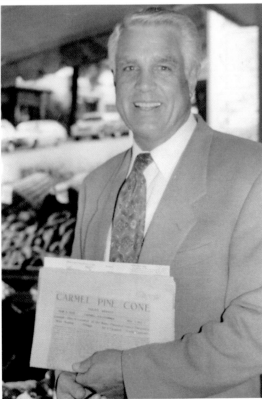

**Merv Sutton (1938)**
Many people assumed his last name was Nielsen. After marrying Nancie Nielsen and taking the helm of Nielsen Bros. Market, established in 1930 by her father, Walter, and uncle Harold, Merv Sutton developed the family grocery store into a specialty market with a renowned wine shop. In 2004, local residents named the Carmel native Citizen of the Year for his commitment to community through his devotion to organizations such as the Carmel Youth Center and Carmel Chamber of Commerce. In 2013, the Suttons sold Nielsen Bros. after more than 50 years in business together. (Courtesy of *The Carmel Pine Cone.*)

87

### Dick Bruhn (1925–2010)

Although he was well known for his elegant men's and women's clothing stores that contributed to the cache of the community, Dick Bruhn, trained as an aeronautical engineer and stationed at Moffett Field during World War II, loved to fly. Which is why he also loved author Richard Bach's *Jonathan Livingston Seagull*, from which he quoted, "For most gulls, it's not flying that matters, but eating. For this gull, though, it was not eating that mattered, but flight." A man who built dreams and then realized them, he also appreciated Anne Morrow Lindbergh's book *Gifts from the Sea*. (Courtesy of *The Carmel Pine Cone*.)

### Gladys McCloud (1905–1993)

The war was on, and Gladys McCloud could not justify squandering a tank of gas to drive to San Francisco in search of school clothes for her children. So she opened her namesake store in Carmel where, as her girls grew, so did her size ranges. Once the store outgrew its space, she made it a landmark at the corner of Ocean Avenue and San Carlos Street. Hers was a haven for the basics and the beautiful, both of which came home tucked into signature blue-and-white-striped bags or special items sent in the beloved beribboned boxes. (Courtesy of Sue McCloud.)

## Gloria Rittmaster (1927)

Theirs was the kind of store one dressed up for. Women wore suits or daytime dresses. Children sat silent in the salon with the coved white walls and crystal chandelier reflecting across three-way mirrors, as they watched and waited patiently for a treat across the street from Cottage of Sweets. This was Rittmaster, the legendary, mode-of-the-day salon synonymous with the elegance of style mavens Richard and Gloria Rittmaster. Customers became clients in a place that operated more like a woman's club than a wardrobe. Dressed in Prada and Escada, they slipped inside just after lunch to take tea and watch models animate ensembles, illustrating how each might look in the culture of Carmel. Gloria was the principal model for the designer apparel, and she wore it well. (Courtesy of Gloria Rittmaster.)

### Barney Scollan (1944)

In 1972, Barney and Patty Scollan opened Carmel Bay Company in the Seven Arts Building, established in the 1920s by Patty's grandfather Herbert Heron, a Shakespearean actor and playwright who held two terms as mayor of Carmel-by-the-Sea. The building, originally dedicated to literature, performing arts, and visual arts, once housed props for the Forest Theater (also founded by Heron), a formidable collection of first-edition books by western writers, various art studios, and Carmel Art Association exhibits. Carmel Bay Company champions local and regional artisans, carrying an eclectic mix of merchandise from antiques, apparel, gourmet and garden gadgets, and fine art to home furnishings. (Courtesy of Barney Scollan.)

### Jim Ockert (1951)

Khakis, crisp white shirts, and chinos with creases that could slice a tomato. Nothing is quite as clean or as cultured as a cool pair of khakis. Dressed up with a tie or dressed down with a T-shirt; it is about lifestyle. When Jim Ockert opened Khaki's Men's Clothier of Carmel, his goal was to create a lifestyle for his family and cater to the lifestyle of his clients. He has done both. Ockert founded the business on a belief in himself and in the notion that if he built it with the finest-quality apparel on the market, presented with the ultimate in customer service, the people would come. And so they have. (Courtesy of Jim Ockert.)

# CHAPTER EIGHT

# The Cuisine Community

By the early 1900s, the character of Carmel was forming by folks who came down the coast or up the historic highway to the hamlet-by-the-sea, a coastal enclave designed for refuge and revelry. They drank for fun, and they sang for solace. They painted or sculpted or photographed or wrote because they had to; it was more about who they were than what they did. And they spent long hours on the white sandy stretch along a feisty sea, drinking and singing and eating abalone.

Creativity and cuisine remain important to the character of Carmel. Residents are still cavorting and consuming on the beach, but Carmel has since developed a more sophisticated culture that escorts folks up and off the sand and into the exceptional bistros, bakeries, restaurants, and cafés of Carmel.

In a place where the terroir encourages agriculture, the soil supports wine grapes and artichokes, lettuce and strawberries, and the sea is teeming with fish harvested sustainably through the Seafood Watch program, residents and guests are respectfully requiring fresh, organic, artisan-prepared food.

"Food in Carmel always comes back to community," says Jay Dolata, who, with his wife, Chloé, owns bistro Carmel Belle. "We support local farmers and serve organic produce and organic or free-range meats. At the heart of all our decisions is whether it is going to be good for our wellbeing."

Dolata and other local chefs see a shift in Carmel cuisine toward more locally focused fare in a town trying to be more on trend with big city dining, made possible by excellent resources for produce, wine, meat, and cheese, prepared by artisans dedicated to the craft of good food.

The Carmel cuisine community is close knit and committed to creating a place where foodies flock to favorite restaurants, gather at the farmers' market in the park, wander the cobbled streets with ice cream or something to sip, and pick up fresh fruit, artisan cheeses, chocolates, and charcuterie to enjoy at home.

In Carmel, it is the scenery, the setting, the service, and culinary selections that inspire diners to take their time, eat slowly, sip, savor, and celebrate the experience, taking in the blending of flavors, textures, and guests at the table. This is what fresh, organic, artisan cuisine tastes like in the culture of cuisine by the sea. The following pages introduce a few of the foodies by the sea.

### Howard E. "Bud" Allen (1922–2008)

A bon vivant who believed and proved he could do just about anything, Bud Allen's achievements and abilities could have landed him in just about any chapter in this book. The quintessential character came to Carmel in the late 1950s and went to work for what is now the Hyatt Regency Monterey before purchasing and renovating the legendary La Playa Hotel in Carmel. A colorful character who entertained fabulously and gave generously to his community, he created a variety of Carmel businesses, including his wildly popular It's Bud's Pub. (Courtesy of *The Carmel Pine Cone*.)

### Sarah Wood (1961)

She grew up in a farming area on the Great Lakes in Upstate New York and was awarded a fellowship and master's degree in journalism from New York University. After a successful stint as editor and chief of *Absolute Return*, covering the US Hedge Fund Industry, Sarah Wood moved to Carmel with her husband, Rev. Rob Fisher, and their young daughter, upon his invitation to pastor St. Dunstan's Church. They fell in love with the warmth and beauty of the community, instantly feeling at home, and giving Wood a sense of place that rekindled her passion for food and cooking. Living in a world-renowned agricultural area and a community dedicated to fresh, sustainable cuisine, Wood looked into food writing, ultimately establishing her award-winning *Edible Monterey Bay* magazine, part of the Edible Communities network of food magazines, in 2011. (Courtesy of Sarah Wood.)

**Chloé and Jay Dolata (1977)**
Carmel Belle is a Euro-style, counterculture bistro where customers choose from a chalkboard menu and then await the arrival of fresh, organic, artisan food in the casual café setting. Some people bring their dogs. Chloé and Jay Dolata, who met in college, came to Carmel in 2009—a return for Jay, who was raised in the area—to purchase the café and create a casual space to commune in a place where people walk into town, run into friends, feast on fresh food, and feel connected to the community. Their goal at Carmel Belle is to keep it fresh, simple, and focused on friends and family. (Courtesy of Philip M. Geiger.)

**Rich Pèpe (1951)**
If he does not know a patron's name when he or she walks through the door, he will by the end of the evening. One of the epicurean emperors of Carmel, Rich Pèpe owns the popular Little Napoli and Vesuvio restaurants as well as Vino Napoli wine bar and the legendary Carmel Bakery, established in 1906 and currently under his care. He also is in partnership in Peppoli restaurant in Pebble Beach and has a line of wines and sauces with actor Joey Pantoliano, famous for the *Sopranos* and infamous as Pèpe's pal from his New Jersey childhood. Pèpe, who has a strong presence in his restaurants and in the politics of Carmel, even took a run at mayor. (Courtesy of Randy Tunnell.)

**Wendy Brodie (1951)**
Celebrated executive chef Wendy Brodie is known as much for her gracious generosity as for the artistry with which she designs and creates food. A graduate of the California Culinary Academy of San Francisco, the Carmel resident was co-owner, with husband, Bob Bussinger, of the Lincoln Court Restaurant, renowned for excellent food and exquisite presentation. Star of her own weekly television show, *Art of Food with Wendy Brodie*, and owner of Art of Food Catering, Brodie's creative approach to cuisine has led her to cook with many celebrity chefs in venues around the world, often for charitable causes. (Courtesy of Wendy Brodie.)

**Pamela Burns (1955)**
All one has to do is notice the size of her chocolate chip cookies, crispy on the edges and soft in the middle, or her specialty, three pounds of apples baked into one pie the old-fashioned way, with lots of butter and sugar, to know that Pamela Burns—locally renowned baker and chef who brought the community Monterey Pasta Company, Baker's Wife, 6th Avenue Grill, and Wild Plum Café— is in the kitchen. Each of her culinary ventures has seemed highly successful, and most are still fruitful, though under new ownership and, in some cases, new names. Most importantly, for Burns, each has provided her with a bounty of followers and a recipe for her next venture. (Courtesy of *The Carmel Pine Cone*.)

### Walter Georis (1945)

He was born in Belgium at the end of the war, and his mother sought refuge in a wine cellar in a neighboring village. It was there, amid the depths of despair and vintage wine bottles, that Walter Georis entered the world, not nearly as afraid as his mother. He was also born inspired. Georis cofounded a boy band before Justin Timberlake's mother was old enough to date. He became a photographer and a painter and joined the Carmel Art Association. Then he got into food and wine. He opened La Bohème, Casanova, Fandango, Georis Winery, Corkscrew Bistro, the Belgian Bakery, Collage, and La Bicyclette, creating an exceptional epicurean enclave on the Peninsula. (Courtesy of Philip M. Geiger.)

### David Fink (1957)

For Carmel hotelier and restaurateur David Fink, the denouement is in the details. Which is why his first Carmel restaurant, Bouchée, opened in 2002, and his showpiece, Aubergine at L'Auberge Carmel, opened in 2004, attract top-tier chefs and discerning guests who have come to expect and appreciate the elegant, couture cuisine crafted from fresh local produce, meats, and seafood. "We filled a niche," says Fink. "There was no luxury hotel in Carmel that also had fine dining. You had to leave your hotel to get a world-class meal." (Courtesy of David Fink.)

### Bill Lee (1953)

He got his first job in a local restaurant by walking in and securing a spot in the dish room. Bill Lee was 16. Four years later, he was waiting tables but quickly advanced to general manager of the now-legendary Sardine Factory restaurant on Cannery Row. By 1982, he had opened Billy Quon's in Carmel, his first of nine restaurants to come. He had just turned 29. Billy Quon's brought a certain panache to the Peninsula, with a savory menu, sophisticated bar scene, and Lee's stainless-steel DeLorean parked out front. It was fresh, it was festive, and it was fun. Lee, with his wife, Teresa Raine-Lee, has continued to drive a contemporary culinary culture with his many Carmel eateries, among them Bahama Billy, Bixby Martini Bistro, and Volcano Grill. (Courtesy of Bill Lee.)

### Cal Stamenov (1959)

Even before the restaurant opened at the new Bernardus Lodge in 2000, the arrival of affable and artistic executive chef Cal Stamenov set precedence. His "California-French cuisine with wine country influences" follows three areas of focus: the relationship between food and terroir (the environmental conditions under which food is grown), the superiority of handcrafted, artisanal products over mass-produced food, and the practice of glorifying food when its flavor is at its peak. The graduate of California Culinary Academy sharpened his knives at New York's Four Seasons restaurant before coming to California as chef de cuisine at Domaine Chandon Restaurant in Napa, and executive chef for the Highlands Inn in Carmel. (Courtesy of Bernardus Lodge & Spa.)

**Csaba Ajan (1942)**
Hungarian-born Csaba Ajan was working as food-and-beverage manager at Hotel del Coronado when, while traveling from San Diego to San Francisco, he stopped in Carmel along the way and decided to move there. Meanwhile, Ed Haber was looking for a manager for his boutique hotel and restaurant, the Covey, adjacent his golf course, Quail Lodge & Golf Club, in Carmel. Ajan managed both for 19 years before leaving to manage construction and operations of the Monterey Plaza Hotel. Two years later, he opened two Carmel restaurants: Merlot Bistro, a casual, family-style restaurant, and PortaBella, an upscale Mediterranean restaurant. (Courtesy of *The Carmel Pine Cone*.)

**Anton "Tony" Salameh (1951)**
He greets his guests with the same gracious elegance as his restaurant, Anton & Michel, the flagship of a group of eateries in downtown Carmel operating under Carmel Preferred Restaurants. Tony Salameh established Anton & Michel in 1980 with his cousin Michel, yet he remains the sole proprietor of the European-style restaurant, which has transformed over the years to a more modern American aesthetic. In 1994, Salameh opened The Grill on Ocean Avenue, which presents California cuisine catering to tourists yet loved by locals. And he partners with Csaba Ajan, the man he calls his best friend, in PortaBella and Merlot Bistro, also on Ocean Avenue. (Courtesy of Philip M. Geiger.)

97

### Tony Tollner (1953)

Whether one is dining on creative country cooking at Tarpy's Roadhouse, savory Southwest cuisine at Rio Grill, or the sustainable, organic fare at Montrio Bistro, the experience is Downtown Dining, the corporation that sets the table at these three celebrated restaurants on the Monterey Peninsula. This trifecta did not happen all at once, but over time, like a recipe that gets refined through generations of cooking. Tony Tollner, who has been involved in Downtown Dining since its inception, was working as a server at MacArthur Park in Palo Alto when he came to the Monterey Peninsula to celebrate his 30th birthday with the general manager of Billy Quon's restaurant in Carmel by doing a little hang gliding off the coast. He finished the weekend with an offer to work for the popular restaurant, which he later turned into Rio Grill. And that was just the beginning. (Courtesy of Randy Tunnell.)

# CHAPTER NINE

# The Carmel Characters

The character of Carmel exists as much in its community as in its coastline. In culling through hundreds of photographs to give faces to the stories that have played out on this singular stage, each one represents a particular moment accounted for in someone's life. Each tells a story of who they were by an expression that shows how they felt, a gesture that shows what they did, a circumstance that shows who they were. Each is meaningful. Each matters. And for each, the moment, now past, is preserved.

It is evident in the grit, the grime, and the glance of Jim Kelsey as he took a water break while fighting the Mission Trails Park fire in 1980. It is found in the youthful beauty of Jackie Young Salazar, who fought cancer in her 20s and won, simultaneously creating Young Cures, a nonprofit organization designed to help others do the same. It is witnessed in the elegance of socialite Virginia Stanton, whose largesse supported the causes of youth and elders, music and theater, history and heritage, art and AIDS. It is recognized in the joyful intensity of Enid Sales, who devoted her life to the historic preservation of Carmel-by-the-Sea.

There is honor to be given and responsibility to be upheld in presenting the photographs and stories of each person. For every Carmel character included among the few who will fit within the pages of this chapter, hundreds of others also deserve to be recognized. It is not hard to select who will be honored; it is not easy to leave anyone out.

Most everyone who has ever lived in Carmel likely would be worthy, whether for spirit, scandal, or sensation, of being profiled in this book. Whether here by birth or brought here by some particular pursuit, Carmel characters know who they are and what they represent.

Carmel founder Frank Devendorf, a developer who married a musician and later went into real estate, harbored a vision of a bohemian enclave by the sea, which motivated him to buy land and establish the Carmel Development Company; Frank Powers, a San Francisco attorney educated at UC Berkeley who married artist Jane Gallatin, began to buy coastal land in what would become Carmel. The collaboration by these two characters put Carmel on the map and created a community so others could come.

**Ruth G. Watson (1898–1980)**
Her skin was soft and lined like crêpe de chine and lightly dusted with powder. Wearing Eva Gabor wigs and St. John knits with sensible shoes for walking, her apparent height was an illusion of pride and good carriage. Ruth Watson was a gracious woman of uncommon wit and presence who spoke in opening lines and penned a social column. The quintessential Carmel character, she placed a man's hat and pair of boots outside her cottage door to thwart intruders, carried the contents of her purse in a brown bag because no one steals lunch, and finally agreed to cataract surgery after realizing she was greeting the headrests in parked cars on her daily stroll to the Carmel Post Office. She also taught writing and took ballroom dancing lessons at the Carmel Foundation senior center, volunteered her time at organizations she believed in, and tried to teach her grandchildren to eat beach spinach. (Courtesy of Leslie Adams.)

### Viola Mills (1903–2004)

A hummingbird of a woman, quick and alert and seemingly fragile, Viola Mills had a feisty side, betrayed by violet eyes that danced when she laughed. Viola moved to Carmel from Lodi in the 1960s, after her husband died, saying she would rather drink wine in Carmel than grow grapes in Lodi. But all she really did was take tea in the hamlet by the sea and reminisce about the "old days in the valley." She also loved to volunteer, gussy up for fundraisers, and serve on every board that mattered or made sense. (Courtesy of Lisa Crawford Watson.)

### Ruth Goddard Bixler (1900–1987)

Psychologist Ruth Goddard Bixler, Carmel's only professional astrologer, came to Carmel in 1928 after spending two years in Hollywood, where she cast the horoscopes of celebrities. She was quick to clarify that the science of the stars and their influence on human life is not fortune-telling. It predicts not the future but the probable course of events or conditions. Bixler believed there were no destructive tendencies that could not be channeled constructively, no difficult periods that could not be avoided if one knew how to handle them in advance. "The fault," she quoted from Shakespeare, "lies not in our stars but in ourselves." (Courtesy of Cristin DeVine.)

### Virginia Stanton (1903–1994)

A freshman stared at the handsome young man watching the Freshie Glee Club make decorations for an upcoming event. He was Robert Stanton, big man on campus and captain of the crew team. The freshman was Virginia Young, a sorority girl whose father had sent her to UC Berkeley because, unlike the social mores of the day, he believed she needed advanced education. The pair married after their first date, and Virginia went onto become the local "Grande Dame of Philanthropy," whose Carmel Valley home was the focus of a 1949 issue of *House Beautiful.* She died at 91 with the grace and dignity of a woman who knows when it is time to leave the party. (Courtesy of *The Carmel Pine Cone.*)

### Enid Sales (1922–2008)

It did not take long for Enid Sales to fall in love. The first time she came to Carmel, in 1933, she was smitten and knew the hamlet by the sea was where she was meant to live out her life. She quickly learned the lay of the land, gathered the stories, studied the architecture, and appointed herself custodian of the community. In her 80s, she took the title, becoming executive director of the Carmel Preservation Foundation, and continued to protect this small artistic and intellectual community and champion the community's responsibility to preserve its character. (Courtesy of *The Carmel Pine Cone.*)

**Bettie Greene (1903–1998)**

She bought her first horse before she turned 16. After her father, renowned architect Charles Sumner Greene, moved the family from the privileges of Pasadena to the untamed village by the sea, Bettie Greene looked at the unpaved Main Street and tangles of trees and saw it as her chance to build a life outdoors. Once she had collected 13 horses, she bought a property on the corner of Junipero Street and Fifth Avenue and opened a stable, where she began breeding horses and giving lessons to just about every child in town. Often called an incorrigible, headstrong soul who broke all the rules, she was known as a tough teacher who taught kids to buck up, saddle up, and never give up. Several children later reported that her lessons are what brought them home from war. (Courtesy of Alice Cory.)

**Jim Kelsey (1924–2004)**

He opened the legendary Rinky Dink Café in 1955 and ran it for 23 years across from the fire department in downtown Carmel, for which he served many years as a volunteer fire fighter. Jim Kelsey, a 1942 Carmel High School graduate, never missed a home football game in more than 25 years. He supported student athletics his entire life and was an ardent advocate for his alma mater and a longtime umpire for the baseball team. (Courtesy of *The Carmel Pine Cone*.)

**Earl Nightingale (1921–1989)**

He was one of the few survivors aboard the battleship *Arizona* after the attack on Pearl Harbor in 1941. Perhaps that had something to do with his becoming one of the most grateful and positive motivational speakers in history. Earl Nightingale, a radio show host and author often called the "Dean of Personal Development," landed on the notion that "we become what we think about" and used it to foster an inspired life for himself and his national audience. In 1956, Nightingale published *The Strangest Secret*, often called the most motivational text of all time. And, in 1985, he was inducted into the Association of National Broadcasters, National Radio Hall of Fame. (Courtesy of *The Carmel Pine Cone*.)

Donald Scanlon (1930–2013)

An internist specializing in cardiology, Donald Scanlon moved to Carmel in 1961 with his wife and five daughters. He resided in the same home for 52 years. An avid sportsman and outdoor enthusiast, he loved to hike along coastal trails and in the Sierra Nevada Mountains. A private pilot, he flew his Cessna from Monterey to Mammoth Lakes on weekends to his family cabin. One of his primary passions was his private medical practice in Carmel-by-the-Sea, where he was known for making house calls. Even after a 1976 bicycle accident left him a quadriplegic, Scanlon continued to make his rounds. He became director of Cardiology Services at Community Hospital of the Monterey Peninsula, serving in that role until 2001. He continued to play outdoors, often racing along Scenic Road in his wheelchair, taking in the beauty of Carmel Beach. (Courtesy of The Carmel Pine Cone.)

**Clyde Klaumann (1939)**

He was recovering from back surgery at Community Hospital of the Monterey Peninsula when three nurses recognized him as their former middle school math teacher, and he remembered their names. Some 40 years had passed since Clyde Klaumann taught at Carmel Middle School and before that at Sunset School and Carmel River School, all schools he had attended as a boy. But his impact on his students and their impression on him has endured. Anyone who sat in his class still calls him "Mr. Klaumann." The past president and current board member of Carmel Lions Club enjoys volunteering for his community through the organization that hosts events and helps people in need, while remaining largely unheralded. (Courtesy of *The Carmel Pine Cone*.)

**John Odello (1943)**

When harvesting more than 300 acres of artichokes, John Odello never wore gloves. They got in the way of his technique—the flick of his wrist that helped him cut hundreds of chokes per hour while avoiding the thistle's spiny defenses. That anyone first found it edible is a testament to curiosity, to persistence, to risk, and to Odello, who grew up in the first family of artichokes in Carmel. Theirs was a community sustained by artichokes. It was their lifestyle and their livelihood, their daily bread and the currency with which they bartered for everything else they needed. Odello still eats artichokes just about every day. (Courtesy of *The Carmel Pine Cone*.)

**Tom Gieser (1950–2013)**
Better known as "Tom the Butcher," the affable expert behind the meat counter at Bruno's Market in Carmel, Tom Gieser, was perhaps best known for remembering just about everyone's name on the other side of the counter, offering cooking advice and recipes to those who asked, and preparing turducken, a holiday favorite of a boned chicken inside a boned duck, stuffed inside a boned turkey, made popular by NFL commentator and Carmel resident John Madden. Yet the hunter and sports fisherman left a vacancy behind the meat counter when he died at 63 while trying to reel in a 100-pound bluefin tuna during an annual fishing trip. Reportedly, despite his heart attack, neither he nor the fish was willing to give up. (Courtesy of Kerry Sanchez.)

## Milton A. "Skip" Marquard Jr. (1938)

It was his grandmother who nicknamed him Skip, and he has thanked her ever since. Skip Marquard shares more than a name with his father. Both trained and excelled under the same coach at UC Berkeley, track-and-field legend Brutus Hamilton. Born in Carmel, Marquard lived in town for four years and then returned after college to go into the real estate brokerage and development business with his uncle and mentor, Paul Porter. He, Marquard believes, was the blessing that governed his career. From 1998 to 2002, Marquard, an Oakland Athletic League mile champion in his youth, served as the head track coach at Carmel High School, for which he provided the poles and pads that still bear his name, to elevate his team into the high jump and pole vault. (Courtesy of *The Carmel Pine Cone*.)

**Bill Burleigh (1935)**
By age 40, Bill Burleigh, who served as city attorney for Carmel for seven years, followed by 22 years on the bench in Monterey County, found himself overworked, overweight, and living a lifestyle characterized by smoking, drinking, and stress. Someone suggested he start running, and then he never stopped. Burleigh founded the Big Sur River Run, a 10-kilometer footrace designed with charitable giving in mind. Four years later, in 1984, he decided to extend his reach. He invited 15 running buddies to gather in Carmel to create the now legendary Big Sur International Marathon in one of the most spectacular settings in the world. Three decades later, Burleigh is as proud of that race, which begins in Big Sur and crosses the finish line in Carmel, as he is of his legal career. (Courtesy of *The Carmel Pine Cone*.)

**Cristin DeVine (1970)**
Hiking through the desert as a therapeutic wilderness guide for hardcore drug addicts, competitive triathlete and marathoner Cristin DeVine was up to the physical challenge but was emotionally and physically depleted. She was leading the trek as part of her career and because it was who she thought she was supposed to be—tough. A licensed marriage and family therapist with a master's degree in psychology and another in education, DeVine was muscling her way through life. Yet, in 1998, she discovered NIA dance, a practice of sensory-based movement that draws from martial arts, dance, and healing arts. Through NIA, DeVine is now teaching others how to be strong without needing to be tough. (Courtesy of Cristin DeVine.)

**Dani Marr (1937) and Barbara Windham (1940)**
They came to Carmel for a decade, during which they restored the charm to a Carmel cottage and embraced the community as if they had been born to it. Among many contributions, Dani Marr and Barbara Windham became active volunteers for the American Red Cross, driving the emergency response vehicle during the storms of El Niño, and they cofounded the Carmel Breast Cancer Assistance Group to raise funds and provide practical assistance to women in the community. (Courtesy of Lisa Crawford Watson.)

**Lacy Williams Buck (1941)** Writer, historian, and philanthropist Lacy Williams Buck is in love with the past, particularly when it comes to the history of her native Carmel, an avocation bordering on passion. Three shelves in the library of her gracious Carmel home are full of books by local authors. Two more bear books written about the area. Another set of shelves is filled with books written by her mother, author Mona Williams. In 1977, Buck came upon *Carmel at Work and Play*, a forgotten little book published in 1925 by Daisy F. Bostick and Dorothea Castelhun. Enamored of a text that revealed a Carmel of "pine-needle paths and unpaved roads, of simple gaiety and abalone feasts on moonlit beaches," she put the book back into print. In 1991, it went into its fourth printing and is available in the local history room at the Carmel Library, which Buck endowed in honor of her father, writer Henry Meade Williams. (Courtesy of Lacy Williams Buck.)

**Bing Crosby (1903–1977)**

In this area, people tend to connect Bing Crosby with The Crosby, the pro-am golf tournament he established at Pebble Beach in 1947, having launched it a decade earlier in Rancho Santa Fe. The event, now known as the AT&T Pebble Beach National Pro-Am, was always about giving back to the community. So it is not surprising that, in 1949, the crooner donated enough funds to establish the Carmel Youth Center, a nonprofit organization dedicated to providing a positive and academically supportive environment in a safe, substance-free space for the youth of Carmel and neighboring communities. The center helps children develop strong character, values, and citizenship by encouraging volunteerism, peer mentoring, performing and visual arts, and academics. Crosby eventually helped establish more than 200 private, nonprofit youth centers across the country, of which only the Carmel Youth Center remains. (Courtesy of the Carmel Youth Center.)

### David Armanasco (1948)

Although he grew up in Carmel, David Armanasco's first language, his mother tongue, was French. He remembers his beautiful French mother as particularly active in community affairs—acting at the Golden Bough Theater in Carmel, volunteering as a pink lady at the hospital, and entertaining graciously in their Carmel home. Throughout his childhood, Armanasco's parents enrolled him in local theater programs, which put him on the stage at Carmel's legendary Circle Theater of the Golden Bough Playhouse and the outdoor Forest Theater. Armanasco's pride and his priority are his family. Otherwise, his commitment to the community inspires his philanthropic largesse on behalf of education, conservation, agriculture, and the arts. (Courtesy of David Armanasco.)

### Marie Wainscoat (1947)

She looks at life with a creative eye and a compassionate heart. The wife, mother, grandmother, registered nurse, and member of the first family of baking who brought Layers Sensational Cakes, Pavel's Bakery, and other indulgences to the community, Marie Wainscoat has had a longtime affair with art. Dedicated to providing access to legendary local artists and preserving their stories before all that remained was their art, during more than 10 years, Wainscoat and her husband, Paul Boczkowski, videotaped interviews with some 40 longtime Carmel-area artists. The result is the documentary *Longtimers: Senior Artists of the Monterey Peninsula I&II* . . . and priceless perspectives preserved. (Courtesy of Marie Wainscoat.)

Jackie Young Salazar (1981)

She would awaken from the most delicious dream and reach into a morning stretch, which would pull on the IV in her arm. Then she would run her fingers across her bald head and remember. These were the moments when Jackie Young, diagnosed at 22 with stage IIIB Hodgkin's Lymphoma, would think, "Fuck cancer." So she customized a T-shirt for herself with the phrase emblazoned across the front. Printed on the back was the word "Survivor." Her shirt was intended for a humorous escape, to be worn among friends and family. But once she found the guts to sport it at Stanford Cancer Center, she was shocked by its impact—everyone wanted one. She was inspired to establish Young Cures, a nonprofit organization whose inspirational T-shirt line raised funds to provide support for young cancer patients. (Courtesy of Jackie Young Salazar.)

# CHAPTER TEN

# The Canine Community

Dogs love the beach. The salt air, the wind in their fur, the wet, sticky sand—the chase of the shore birds, the seaweed, the stick, each other. The freedom to be who they are, unleashed and unguarded, is the promise of a dog day at the beach.

This may explain why canines crave Carmel. Or it may be because, while tethered to their owners as they stroll the streets of the city by the sea, passersby stoop to pet them. Shopkeepers set water dishes by the door and keep dog treats at the counter. Carmel Bakery makes a subtle distinction between biscuits meant for dogs and those prepared for people. And while food and beverages must be parked outside many stores, dogs are usually invited in.

One need not know about Carmel's canine calendar, posh pet portraits, or pampered pet boutiques. Or the late George Rodrigue's Blue Dog paintings, the Fountain of Woof watering hole at Carmel Plaza, or even past canine companion sculpture competitions, to understand that Carmel has gone to the dogs.

One stroll through town is all it takes to understand Carmel caters to canines. Many restaurants accommodate dogs, and Doris Day's Cypress Inn encourages them. Carmel Belle, a European-style bistro, has a section with tabletop signs that welcome dogs. PortaBella Restaurant invites patrons to park their pups at their feet in the patio dining room at the back or by the outdoor seating in front. Dogs rest underfoot in the outdoor dining room at the Village Corner Restaurant.

But to really understand Carmel's commitment to canines, check out the arc of white sand that frames Carmel Bay to witness the social dynamic and diversity of dogs and their owners who frequent Carmel beach. These are the regulars who show up on the sand after the tides but before the tourists to run free and unfettered by the sea. This is the morning group, that elite cadre of canines who come practically before the birds to get in a little romp and happenstance until their people have finished their coffee and conversation. There also is an afternoon alliance, that crew of motley mutts who ease into morning then meet after their nap to run amok along the shore. With the wind in their faces and the sand in their fur, they are living their bliss by the sea.

Particularly vocal advocates have been actresses Joan Fontaine, Betty White, and big-band singer and an animal rights activist Doris Day, whose nonprofit organization, the Doris Day Animal Foundation, has promoted the welfare of animals since 1978.

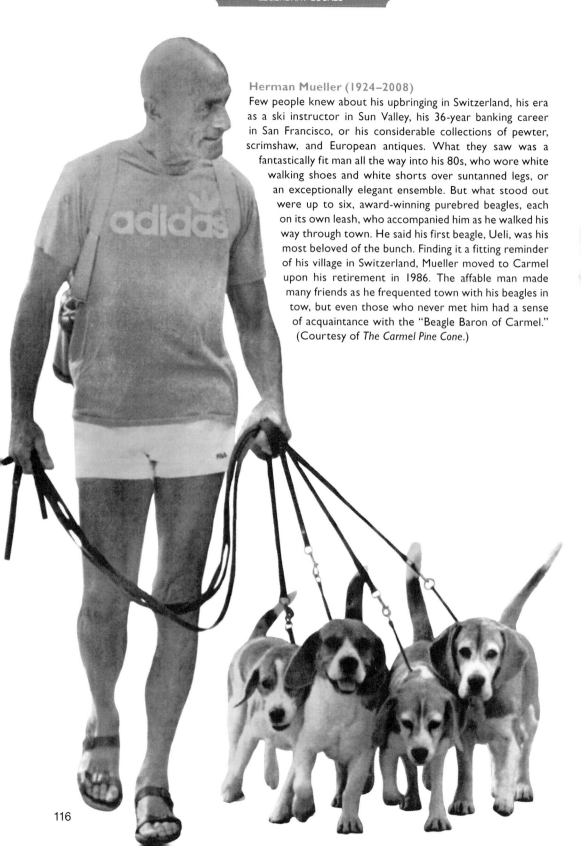

**Herman Mueller (1924–2008)**
Few people knew about his upbringing in Switzerland, his era as a ski instructor in Sun Valley, his 36-year banking career in San Francisco, or his considerable collections of pewter, scrimshaw, and European antiques. What they saw was a fantastically fit man all the way into his 80s, who wore white walking shoes and white shorts over suntanned legs, or an exceptionally elegant ensemble. But what stood out were up to six, award-winning purebred beagles, each on its own leash, who accompanied him as he walked his way through town. He said his first beagle, Ueli, was his most beloved of the bunch. Finding it a fitting reminder of his village in Switzerland, Mueller moved to Carmel upon his retirement in 1986. The affable man made many friends as he frequented town with his beagles in tow, but even those who never met him had a sense of acquaintance with the "Beagle Baron of Carmel." (Courtesy of *The Carmel Pine Cone*.)

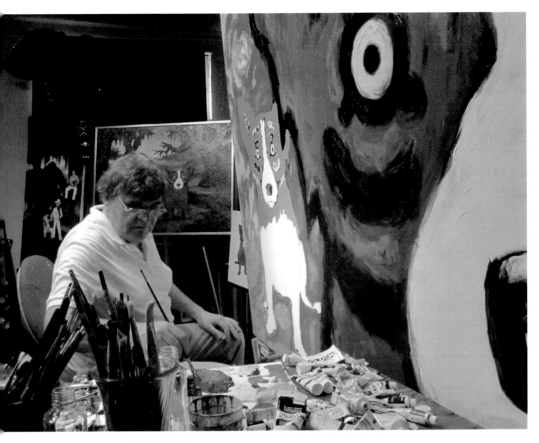

### George Rodrigue (1944-2013)

The Blue Dog took shape in the mind of artist George Rodrigue many years ago. When he was little, his mother told him stories of the loup-garou, a werewolf or ghost dog, which would haunt him, she warned, if he did not behave. Later, as a Cajun folk artist, Rodrigue painted a loup-garou, referencing a photograph of his beloved dog Tiffany upon her death. He painted her in front of a haunted house and cast her in a blue-gray tint to echo the pale blue moon in the sky. Her red eyes looked scary, and her rough fur seemed wild. This was the beginning of the Blue Dog. The style of the Blue Dog changed as the artist's painterly impressions shifted. Where red eyes looked evil, yellow eyes seemed curious, kind. The rough fur seemed earthly; the absence of brush strokes appeared ethereal. The pale gray-blue color was common; the cobalt blue was original. (Courtesy of George Rodrigue Foundation.)

Marisa (2003)

She sits on her tuffet with all the regal bearing of someone used to receiving royal treatment. As a Russian wolfhound-borzoi blend, with her long limbs, graceful neck, narrow face, and black-and-white fur brushed until it falls in soft waves, Marisa has the bearing of a blueblood. After gracing the entrance to a Carmel art gallery and greeting the guests as they come in, the queen of Carmel's canine community has 12 years of indulgence in her sense of self. She does not ask for attention, but she allows it. She keeps her own countenance, yet is still engaging. This is why she is likely the most photographed dog in Carmel and has sat for many painted portraits, holding her head high like any diva willing to suffer for art. (Courtesy of Joanna Chapman.)

**Andee Burleigh (1967)**
The founder and owner of Divine K9 dog training, Andee Burleigh brings out the supremely good nature in dogs. Dog spelled backwards is god, she says, and she believes they who bring a little slice of the divine into our lives deserve to be trained with compassion. Burleigh was voted by her high school class "Most Likely to Succeed Mutual of Omaha's Wild Kingdom Host Marlin Perkins." To this day, she does not feel complete without one or two dogs, or the pack of six—four clients plus her own two—she often is seen training or walking throughout Carmel. (Courtesy of Andee Burleigh.)

**Sarah Adams (1953)**
She entered the raw food business in a battle against the short lifespan of her beloved Irish wolfhounds. Once she switched her dogs from kibble to raw food, within weeks the hounds hit ideal weight, had glossy coats, and were back on the beach, running with the energy of a pup.

In 2002, Sarah Adams launched a raw food home-delivery business, which led her, four years later, to open the Raw Connection in Carmel. The facility also has three treatment rooms for chiropractic care, reiki energy healing, and acupuncture, plus training and agility classes. In an era of purse puppies, party clothes, and a privileged place at the table, Adams sees a raw-food diet as a healthy way to pamper a pet. (Courtesy of Sarah Adams.)

### Todd Harris (1964)

Having shown dogs for years and loved them for longer, Todd Harris, a longtime member of the Del Monte Kennel Club, considered himself heir to the throne when he purchased Suds 'N Scissors in 1995. Established in 1965, the Carmel pet spa, boutique, and concierge pet service has always had a dog-show flair, specializing in standard poodle and show clips, yet Harris, a former dog-show handler and groomer, welcomes all to his elegant dog-and-cat–grooming retreat. (Courtesy of Todd Harris.)

### Robert Little (1988)

Putting a pooch in a purse is more of a present for the person than for the dog. It is fun and fetching and absolutely adorable, which is why, since 2003, specialty shop Diggidy Dog, which carries an eclectic array of dog and cat accessories, is so wildly popular, particularly in a canine community like Carmel. Diggidy Dog presents 2,000 square feet of grooming tools and gourmet treats, beds and bowls, leads and leashes, and purses and party clothes. General manager Robert Little promises it is all designed with pets in mind. (Courtesy of Philip M. Geiger.)

**Posha (2012)**

This Cavalier King Charles spaniel loves to walk uptown and greet people who find him irresistible as he looks up with that earnest little face and those big brown eyes. Posha's people bring him to the Cypress Inn for tea, where he communes among canine companions. They also introduced him to Carmel Beach, home of the annual Cavalier King Charles Spaniel Carmel Beach Party. He loves the sand, but he is a little wary of the water. A tad intimidated by big dogs, he rolls over onto his back and looks up with those big eyes, as if to say, "I dare you to attack something so cute." (Courtesy of Marcia Harrington.)

**Marki Miner (1980)
and Josh Fickewirth (1980)**

Carmel natives Marki Miner and Josh Fickewirth met in elementary school, fell in love in high school, and married in 2008, the same year they opened Grooming by the Sea. Although both are lifelong animal lovers, Miner got her first job grooming horses at 12, and by 14 she had become a professional groom for horse shows. She later worked on a dude ranch before settling into pet grooming, her favorite role because of the family-like relationship they build with people and their dogs in the canine community they call home. (Courtesy of Marki Miner and Josh Fickewirth.)

**Geno (2005), Lulu (2008), Hugo (2012 ), and Rockin' Rooney (2001)**

Their person promised her husband she would get just one French bulldog—at a time. She began with Geno, who has a byline in Carmel's *Doggy Gazette*. Next came little Lulu, a high-maintenance model who has sat in the spotlight for Carmel photographers and some San Francisco spreads. Baby Hugo is pudgy and pasty, a Winston Churchill doppelganger, who drags around his dinner dish in search of handouts. Even she thought three French bulldogs was enough. But then she learned about Rooney.

Beaten beyond hope, at two years, he weighed 10 pounds instead of 27, and his digestive system no longer worked. Peace of Mind Dog Rescue asked for her help. She gave him a special liquid diet and ice cubes that felt good in his mouth. She coaxed him out of his crate when he was scared and held him through the night. While she taught him how to walk again, her other three dogs taught him how to play. Rockin' Rooney now weighs 23 pounds. He still loves those ice cubes, which he coddles and kisses and carries around, proud of his little possessions. (Courtesy of Jeff Bushnell.)

**Spencer (2013) and Beamer (2010)**
A 1951 Plymouth Suburban sits rain soaked outside Starbucks, the droplets of water beading up on its freshly waxed, hunter-green paint. Vintage travel stickers decorate the side windows, and "Stone Cottage" is stenciled in red across the front doors, in reference to the family home in Carmel. The hood ornament is a sturdy silver dog, and the license plate reads "Dogs 51," a nod to the most prominent feature of the car, two golden retrievers poking their heads out the side windows as they wait, their eyes soft, and their red coats shining complement to their green car. Their person bought them the car. "It is all so East Coast," he says, "but it seems to fit Carmel."

### Jenni Field (1961)

Growing up, she had mutts. But when her children were little, and she was providing professional childcare, she wanted a predictable breed. So she bought Angel, a purebred yellow Labrador retriever. Over the years, she bred Angel and her offspring Halo, resulting in some 30 puppies, most of whom have remained in Carmel, and bringing her own pack to four labs, with the births of Daisy and Willow. In 2006, Field lost her 17-year-old son Ryan to a car accident, over the cliffs of Big Sur. She has no idea what she would have done without her dogs, who were there for her, unconditionally. Halo was humor, Daisy was loyalty, Willow was affection, and Angel was her strength. They still are. (Courtesy of Philip M. Geiger.)

### Judy Kreger (1950)

She did not have a dog until she was 36. Now she has five, all Labrador retrievers, often seen cavorting together on Carmel Beach. After volunteering 27 years for Golden Gate Lab Rescue in San Francisco, when she moved to Carmel, Judy Kreger decided to establish a local rescue organization. At Monterey Bay Labrador Retriever Rescue, every dime goes to the dogs, people trust that every dog is lovingly fostered, and the staff is sensitive to the challenges in surrendering or seeking a lab. (Courtesy of Judy Kreger.)

**Betty White (1922)**
She was not supposed to get the part. When they could not find the "Betty White type" they were looking for, producers gave her a shot. Betty White owned the role of "happy homemaker" Sue Ann Nivens on the 1970s *Mary Tyler Moore Show* as if she had been born to it. Audiences also adored her as the naïve Nordic Rose Nylund on the 1985–1992 *Golden Girls*. White, president emeriti of the Morris Animal Foundation, who often brings her love of animals into her onscreen personae, is also renowned for her work in animal welfare. "You can always tell about somebody," she has said, "by the way they put their hands on an animal." At 93, White continues to delight with roles in film and television, and the actress, author—she published two books in 2012 and has another on her desk—and animal rights activist shows no signs of slowing down. Although she lives in the same home in Brentwood, California, that she shared with beloved husband, the late Allen Ludden, host of legendary game show *Password*, White also has a home in Carmel near close friend Doris Day, who shares her passion and action on behalf of the welfare of animals. (Courtesy of *The Carmel Pine Cone*.)

### Doris Day (1924)

Actress, singer, and animal rights activist Doris Day began her career as a big-band singer in 1939. Although her popularity rose after her first hit recording, "Sentimental Journey," she is perhaps best known for singing "Que Será, Será," introduced in Alfred Hitchcock's 1956 film, *The Man Who Knew Too Much*, and her *Pillow Talk* romantic comedies with Rock Hudson. Yet in 1978, the Carmel resident and co-owner of the Cypress Inn, the decidedly dog-friendly hotel, founded the Doris Day Animal Foundation, through which she has worked tirelessly on behalf of animal welfare. Many believe it was Day who led the development of Carmel-by-the-Sea as the quintessential canine community. (Courtesy of Doris Day Animal Foundation.)

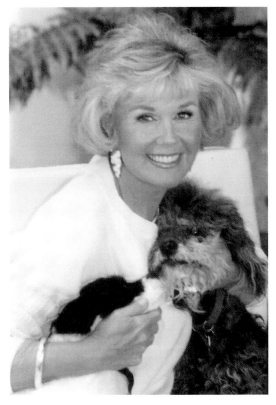

### Joan Fontaine (1917–2013)

She established her Hollywood persona early in her career, and her fans never let go of their sense of the smoldering beauty who could shift from soft to sexy to sinister in a whisper.

For 30 years, Joan Fontaine made her home and life away from the spotlight in Carmel, where she wandered the gardens of her Villa Fontana home and spent time with her beloved pets. Upon her passing, the animal lover left her home and many treasured possessions to the SPCA for Monterey County, from which she had adopted many pets throughout her years in Carmel. (Courtesy of the Library of Congress.)

# INDEX

# INDEX